Safe, Sane, Consensual and Fun

by John Warren, Ph.D.

Safe, Sane, Consensual and Fun

by John Warren, Ph.D.

greenery press

Cover design: JohnnyInk

Published in the United States by Greenery Press, 1447 Park Ave., Emeryville, CA 94608, www.greenerypress.com.

ISBN 1-890159-43-3

Contents

Introduction ... 1

The Guided Fantasy ... 5

The Sensual Seduction .. 15

Spanking ... 21

Discipline.. 25

The Waxing .. 33

The Picnic.. 41

The Cocoon .. 49

The Kidnapping... 57

Embarrassment ... 67

The Conversion ... 79

The Transformation .. 89

Humiliation ... 97

Self-Bondage .. 105

The Enema .. 111

Appendix .. 121

Index.. 124

Other Books from Greenery Press 128

Introduction

Beginners ask me "What kind of a scene can I do?" While scenes are as varied as the people who do them, I've found that what is really meant is "Give me some ideas for a simple, safe scene I can do with my lover." That one is a lot easier to answer.

In fact, it is a very good question. Pornography frequently paints a picture of D&S that is very different from what really happens in the scene. In porn, brutality, oppression and degradation are common. Of even more concern is the presentation of very dangerous activities as if they were part of the repertoire of the average dominant. For example, suspension by the wrists is quite hazardous. Done improperly, it can lead to nerve and muscle damage; if allowed to continue for too long, it can be fatal. Yet, one porn novel after another describes submissives suspended by ropes and left, unattended, for hours. This may be hot fiction, but anyone who tries to duplicate such a scene will discover a different, and horrifying, reality.

First and foremost, D&S is fun. If it isn't fun and exciting for both people, you shouldn't be doing it. A properly done scene arouses and excites everyone involved.

The National Leather Association popularized the slogan from which this book draws its name: Safe, Sane and Consensual. Like most slogans, it is a pointer to reality rather than reality itself. "Safe" is a relative term. For example, most writers now refer to saf*er* sex rather than safe sex. Pure and complete safety is an unattainable absolute. Any activity has inherent risks, and the risks in D&S are greater than in many sexual activities. However, most in the organized scene have a much lower tolerance for "accidents" than those in vanilla life. One speaker at a leather event accurately pointed out that injuries considered beneath notice at a high-school football game would be the talk of the scene for weeks.

Sane is also relative. Do sane people do D&S... mountain climb... sky dive... vote a straight party ticket? Fortunately for us, *The DSM IV* (the Physician's Diagnostic and Statistical Manual, version IV), the primary guideline for psychologists, psychiatrists and other brands of shrinks, defines D&S as pathological only if it bothers you that you like it or if it interferes substantially with your day-to-day life. I assume this means that you insist on being tied to your desk at work or on wearing fetish clothing while attending church. This definition, however, is a relatively recent change, and I suspect a number of recidivistic headbangers would be only too happy to make most of us residents of the sponge-rubber hall... you know, the place with the latex wallpaper.

Consensual is easier. Simply put, both (or all) people taking part in the scene must be capable of agreeing with

what is going on, agree with it, and be able to withdraw their consent at any time without fear or reluctance. This means that anyone under the influence of drugs, alcohol or undue influence is not a proper partner for playing and that criticizing someone for stopping the play is the mark of a poor... and, perhaps, dangerous... player.

Those who like to *play* that they are in a nonconsensual situation use safewords: clear and unmistakable safety signals agreed upon before any playing begins. If the submissive is ungagged, a phrase like "red light" will do. If he or she is gagged, some kind of easily generated signal, like repeated hoots through the gag, must be agreed upon ahead of time. For people for whom nonconsensual role play isn't important, simply saying, "That's too hard" or "Let's stop" is enough. Coded words are not necessary in these games.

However, some sort of agreed-upon "let's stop" signal is vital to safe play. It is not a criticism of the dominant. Things happen that cannot be predicted: muscle cramps, twisted ropes, even heart attacks. The safety of the submissive and the continued consensuality of the scene are the overriding concerns.

The following scenes, told in a narrative style, are designed to stimulate the reader's imagination. Occasional parenthetical comments give tips on technique and safety factors that may not be obvious from the main text. Because of length considerations, I've omitted pre-scene negotiations during which the members of the couple discuss their respective turn-ons and turn-offs, health considerations (for

example, gags should be avoided if the submissive has sinus problems), and other concerns (putting a hood on a claustrophobic is not a good idea).

No one should ever play without considering the risks inherent in this kind of sexual activity. D&S is based on drama and fantasy. When you use these to the fullest, you experience much more intense scenes than any physical activity could produce by itself. Lead the mind, and the body will follow.

The Guided Fantasy

Materials needed:
Recording of sea sounds
Moderately sharp knife
Very dull knife without point
Dildo
Turkey baster with warm milk

Rebecca was surprised to see Paul waiting in a deck chair on the front porch when she pulled in the driveway. When she came over for a scene, he was usually already wearing his "dungeon gear" and waiting impatiently for her to arrive. This new, casual attitude confused her. She joined him on the porch, sat down and accepted a Coke. Then she saw That Book and blushed.

Paul followed her gaze and casually picked up the paperback. Its garish cover showed a bare-chested steroid addict clinging with one hand to the rigging of an old sailing ship while the other hand protectively clutched a red-haired woman whose assets struggled mightily to escape from an overmatched peasant blouse. He smiled and said, "I picked this up when I was over your house last time. It makes interesting reading." He paused, and Rebecca felt her skin

One requirement of a good dominant is to pay attention to the submissive's interests. There are often clues of which even he or she may be unaware.

grow hotter. He fluttered the pages with a finger. "I was particularly interested in the pages you had marked.

"I'm shocked... really shocked... that a woman of your intelligence could be reading such trash." A stew of emotions brawled within Rebecca. She was ashamed. Romance novels were trash, but they were also a wonderful escape from today. She also felt the beginnings of anger. How could he criticize her reading taste? He was her lover, not her god.

Rebecca was so distracted that she didn't notice Paul rising and moving to stand behind her chair. His next words were whispered directly into her ear.

"You shouldn't be reading such trash... you should be living it."

With a sudden motion, he slapped a handcuff on one wrist, pulled her arm behind her, and snapped the matching cuff to her other wrist. Rebecca felt a gasp of passion rise in her, and turned to look at her lover, but he was ready with a blindfold. She had time for only a glimpse of sparkling eyes and a grin before everything went black. She could feel him adjusting the handcuffs and then he said:

"Come with me... into the house and into another century."

He helped her to her feet, but instead of guiding her through the door, he threw her over his shoulder like a sack of wheat. As she felt herself lifted and carried, a feeling of erotic helplessness pervaded her soul. She knew, deep down with the all the certainty in her essence, that she was completely in his power, and she reveled in the feeling.

She felt him climbing stairs, and then she was roughly thrown down on her side onto something soft and resilient. Rebecca wiggled a bit, tugging without effect on the cold metal cuffs that held her helpless. Then she waited, every nerve straining. She heard a few clicks... a gentle breeze reached out and touched her, and she could hear the sound of wind and the creak of strained rope.

There was a soft "poof" and she could smell the bitter tang of burned sulfur. Suddenly, his voice was soft in her ear. "You are a pampered maiden of the Sixteenth Century. You have sailed to the new world to escape the stifling restrictions of Spain, but your ship has been set upon by pirates."

As he spoke matter-of-factly about things of which she had dreamed, she felt her nipples grow hard and her pussy warm. Images flitted behind her closed eyes.

"The crew is dead or dying. Only you've been spared. Look about you and tell me what you see."

Rebecca faltered. *How could he know about the images?* she asked herself. Then, she recovered and spoke.

"I'm on the deck of the pirate ship. They are all around me, cruel and lusting. Only the captain's power keeps them from ripping me apart right now. I'm chained and helpless."

Paul's voice cut through the reverie. "Tell me about the captain."

"He is tall and blond." Rebecca paused wondering if she had made a mistake. Paul was only moderately tall and Mediterranean dark. *Hell,* she thought, *this is my fucking*

Being carried produces an intense erotic feeling among many people. It is a clear manifestation of being helpless.

A person wearing handcuffs could be injured if she were thrown down on her back.

A fan can provide the illusion of wind while specialty stores stock CDs with all sorts of wonderful sound effects. This CD was obtained from a mail-order house specializing in supplying sailboat owners. A cut-up firecracker provides just enough gunpowder to make the air in a room smell like a battle has just taken place.

fantasy and went on. "He has a bare chest and two swords hanging from his belt. He's telling them to leave me alone."

Paul's voice broke in again; only this time, it was louder and harsher than before.

"Back off, you scurvy dogs! I claim the first right with this bitch. You can have her later."

Noooo! Rebecca thought. *That isn't part of it,* but she realized that it was. Paul had seen through her attempt to dominate the fantasy and had reestablished his control over her body. *Over my body... and my soul*, she thought, wiggling in passion.

"Let's see what we have here," Paul said roughly, pulling her to her feet. With one hand under her chin, he held her erect, almost on tiptoes while the other hand roughly undid her blouse and freed her breasts.

Uncharacteristically, she felt shy, almost ashamed, as if she could really see the rough crew taking their pleasure at her humiliation.

"Don't strip me in front of them," she begged, falling into the spirit of the game.

"Ah, the bitch has spirit," Paul said loudly. Then, to her, "Listen, slut, you're here for my pleasure and the pleasure of my crew. Fight me, and we'll strip the skin off you an inch at a time. Please us, and you may survive as a whore in Port Royal."

The images were so sharp that Rebecca almost forgot that this was a game, playacting; she almost became the helpless woman at the mercy of merciless men. It excited her so much that she lost her balance. Only Paul's hand

In later chapters, I will discuss the difference between – and uses of – humiliation and embarassment.

under her chin and the one that clasped one breast with an agonizing grip kept her erect.

As soon as she was steady on her feet, he undid her belt and she felt her skirt pool at her feet. The soft breeze she had noticed before emphasized her growing nakedness. She felt the cuffs dropping from her wrists. Without thinking, she pulled free and took a few quick steps before a heavy hand on her shoulder spun her around. Another hand grabbed a breast. A hand was between her legs, pulling her up and off balance; others seized and spread her legs as she fell on the wooden deck (bedroom floor?) So many hands! She seemed to be held by more than two. Her panties were pulled off and he entered her roughly.

Rebecca screamed in shock. Her damp but unready pussy felt like it was being torn, and then he was inside, welcomed. He seemed huge, larger, much larger than she remembered. The screams became whimpers, gasps and then, again, a scream.

Dazed by the intensity of the orgasm, Rebecca didn't feel Paul withdraw, but she did feel the powerful yank on her hair that brought her to her knees. Through the roaring in her ears, Paul's voice was soft and familiar in her ear. "Tell me about other crewmen."

The images were sharp and clear. She had no idea where they came from, but they were there in front of her. She took a breath and said, "There are two in the front row. One is a small man with sharp features. He has two knives in sheaths across his chest. The other is almost fat with a scar on his face. He is staring at my pussy."

In a successful guided fantasy, the submissive loses himself or herself in the fantasy. Reality and fantasy blur in a most erotic fashion.

Handcuffs can be very dangerous if the person wearing them struggles – and a certain amount of struggle is inevitable with orgasm. For this reason, handcuffs should not be left on during intense sexual activity.

An essential part of a guided fantasy is to blend the submissive's existing fantasy and its images with the spell you are weaving.

Paul's "other voice" interrupted her. "Suck my cock, whore. Taste yourself on it."

Rebecca loved to suck Paul's cock. She fantasized about sucking it for hours, falling asleep with it in her mouth and awaking with it still between her lips. She could come from the feeling of the hard meat between her lips, but now something stopped her. She wasn't Rebecca; she was a proud Castilian woman. The words rose to her lips before she even thought them.

"Never! You can whip me to death before I'll suck your dirty cock."

Paul didn't seem to miss a beat or seem the slightest bit surprised.

"So be it, bitch. But it isn't a flogging that will separate your skin from your worthless body."

In shock, Rebecca felt familiar leather cuffs on her wrists. Roughly, she was pulled erect and pushed against the wall where her arms were pulled up and apart and fastened in place. Only, it wasn't a wall in her mind's eye; it was the rough rigging of a pirate ship. She could almost feel the rough hemp against her back. Rope, wonderful, sensual rope, not cuffs, pulled her legs apart until she was open and exposed. Nothing remained of the clothing she had worn; she was naked and exposed. She could almost hear the whispering of the men watching.

Modern houses and apartments limit the opportunities for bondage, but a few, carefully placed eyebolts (tell the mother-in-law they are for planters) can be very useful. Make sure the bolts are in studs rather than just through the wallboard.

"Mouse," Paul commanded in his Captain's voice, "come here and show our high-born lady how you like to make love."

His voice changed, becoming higher pitched with a barely suppressed eagerness. "Yes, Captain. After I'm finished with her, she'll be anxious to suck your cock."

Rebecca felt a warmth in front of her, a body cutting off the cool breeze, but what touched her was not warm at all. It was cold... and sharp. She shook so violently that her back beat a wild rhythm against the wall. The knife slowly traced a path over first one breast and then the other. The pressure was light and her skin was in no danger, but in the fantasy world, blood began to ooze from tiny cuts that burned with a particular agony. The knife withdrew and something warm and wet took its place. *A tongue. The little man is drinking my blood,* she thought finding a wild excitement in the image.

The knife returned and continued to trace its pattern of agony and ecstasy on her skin. Sometimes, he would stop and press the tip of the knife against her skin, concentrating the sensation in one point. As the knife slid across her throat, Rebecca began to gasp, faster and faster. The knife kept pace with the guttural sounds she was making, sliding faster and faster over her body until it streaked across her pubic mound and slid smoothly into her pussy. Her shriek was earsplitting as the orgasm drove all thought from her mind.

Vaguely she was aware she was hanging from her bonds and unseen hands were freeing her. Passively, she allowed herself to be lowered to her knees. When she felt Paul's erect cock against her cheek, she opened her mouth and took it in. At first, he moved her head with his grip on

Knife play can be very exciting. The trick is to use just enough pressure to provide stimulation without risking cutting the skin. I tend to hold the sides of the blade between thumb and forefinger so if the person moves, the knife moves easily away. A more conventional grip might hold the knife rigid while the person pushed against it, causing unintentional injury.

It is easy to switch from a conventional knife to a very dull butter knife while the person is distracted.

her hair, but as her passion reignited, she took a more active role until she was drawing him back into her throat, feeling the pulsations of his heartbeat against her palate. Faster and faster she sucked until she could feel him expand in preparation for a massive orgasm.

Suddenly, the grip on her hair tightened again and her head was jerked back, her lips sliding along, reluctantly giving up the hard cock. She found herself thrown back onto the deck and her legs roughly parted.

Again, the harsh voice, "Scarface, you've been staring at this bitch; why don't you use her mouth while I try out the virgin's pussy again."

In her mind's eye, she saw the big man advance on her helpless body while the Captain sheathed his meaty sword deep in her pussy. So real was the fantasy that she bent her head back, opening her mouth ready for the heavy man's cock, but it still was a shock when something hard and thrusting pushed her mouth further open and penetrated. Part of her recognized the slight taste of silicone, but for most of her, she was being raped at both ends, helpless before their lust. She screamed, opening her throat for that cock while she wrapped her legs around the Captain who drove even deeper into her body.

Finally, she felt him explode deep within her, filling her with his seed. Then, another voice, said, gasping, "I'm coming, Cap'n. I'm gonna come on the bitch's tits." The cock withdrew from her mouth, and the she heard a low moan and hot cum showered her breasts. *It's impossible*, she screamed to herself and then the final floodgates burst, and she spun away into darkness and starbursts.

Later, as they lay in each other's arms, Rebecca examined the silicon dildo, the knife... and the turkey baster with a few drops of warm milk still in it.

The Sensual Seduction

(Text taken, with permission, from <u>Murder at Roissy</u> by John Warren)

Materials needed:
Handcuffs
Leather or nylon wrist cuffs or other bonds
Massage oil

Michelle heard the knock at the door, took one quick look around the bedroom, and ran lightly to answer it. Ken, tall and dark as ever, reached out to grab her the instant the door was open, but she danced lightly away.

"Not so fast," she said, laughing like silver bells, and pulled him into the room, closing the door behind them with a quick kick. "Let me see your hands," she said, and when he extended his hands, a puzzled expression on his face, she imprisoned his wrists in a pair of handcuffs she had been holding behind her. Before he could react, she said, "Tonight, I'm going to be in charge of your pleasure. Come into the bedroom, darling."

Taking him by the hand, she led him to the upholstered armchair. When he started to protest, she simply put a fingertip to his lips. Pushing him back into the chair, she went over to the room's stereo console and turned it on.

Kneeling in front of him, she waited until the opening bars of *Pachelbel's Canon* filled the room. Gracefully rising to her feet, she lifted her hands above her head and slowly turned so he could admire both the clinging crepe dress and the body within it. Putting her feet wide apart, she began to move in time to the music.

Lowering her hands to her shoulders, Michelle let them slide forward and, then down over her chest until each hand was cupping a breast. She held that pose for a moment, then turned her back to him. Her gently swaying buttocks held his eyes entranced while her hands moved on the buttons that marched downward from the shawl collar. When she turned back, her chest was naked. With a shrug of her shoulders, she let the upper part of the dress fall way from her back.

Slowly, she danced closer to him until he was close enough to see that her nipples were swollen and her eyes were glazing over with lust. Her hands played for a moment with the fastenings at her waist and the rest of dress fell away. She turned and walked away from him, her hips rolling in a rhythm older than language. He hadn't noticed her high heels before, but now the magic they performed on her legs and buttocks was unmistakable. The limbs were thinned, and muscles cast in bold relief. The cheeks of her ass were tight and sculpted like those of a classical Greek statue.

She turned back and flowed toward him, her hands gliding over her body. "Remain still, my darling," she said. "You have made me a very happy woman. This is my way of thanking you for that."

> There is *nothing* in the rules that says the one who is doing the domination can't have fun.

With lingering touches, she explored his body. Her lips followed her fingers as they opened his pants. Slowly, she stoked the fires within. After removing his shoes and socks, she paused and played with each foot, sucking on each toe in turn and licking his ankles. As she knelt before him, he admired the curve of her back as it tapered to her waist and flared into her womanly ass.

He lifted his body automatically to allow her to slide his pants down and off his legs. She helped him to his feet. From a nightstand, she produced a key and unlocked the handcuffs, tossing them to one side before removing his shirt. Ken was surprised to realize that his eyes followed the discarded handcuffs with something like longing.

As noted before, handcuffs can be very dangerous. For this reason, handcuffs should not be left on during intense sexual activity. See page 121.

Rising, she guided him to the bed and positioned him face up on the covers. From the upper corners of the bed, she pulled nylon cuffs and fastened them to his wrists.

The music had shifted to the theme from *Chariots of Fire* as she cupped his balls and poured massage oil on the back of her hand. He gasped and arched as the warm oil seeped between her fingers and came in contact with his skin.

She gently kneaded the sac while studying his erection, the skin tight and the veins making a purplish tracery under the skin. With a tiny laugh, she ran her fingernail along the base of the organ almost to the tip and fell forward on him for a passionate kiss.

Being in control can be immensely exciting, but it can also bring out a feeling of intense playfulness.

He shifted and she enveloped him. Her body stiffened, and her eyes dilated with pleasure. However, she quickly recovered and, putting her hands on his shoulders, pushed

herself into a sitting position. She picked up the plastic squeeze-bottle of massage oil from where it had fallen on the covers and put about a tablespoon of it on his chest. She slowly shifted her weight from side to side as she kept him trapped within her.

A sudden spasm made her stiffen, throw her head back and hiss between her teeth. She began to spread the oil across his chest, running her fingers through his hair to coat it and the skin below with the fragrant oil.

He watched her. His only movement was a widening of his eyes and a slight clenching of his fists as her fingers mapped new trails of pleasure across his skin.

Once his chest glistened in the candle light, she pressed harder and leaned her weight against her arms. The movement brought simultaneous gasps of pleasure from both of them. Her fingers moved, pressing and kneading, as he rolled his head back and arched his back. A gasp escaped his lips.

Her hands were at his neck, warm and slippery. His hips began to move as his self-control slipped.

She ran her fingers, perfumed with the oil, over his cheeks and played with his ears. His hips were driving into hers, and hers were responding with abandon. He could feel her nipples sliding against each individual hair, sending tremors throughout his body.

Her hands, slippery with the oil and clumsy with lust, fumbled with the cuffs, and, then, his hands were free. They rolled over. Once on top, he redoubled his thrusts. The world swam about them, and far away he thought he could

hear her "My darling, my darling" as he filled her to overflowing. Without his volition, his voice joined hers in a long scream that seemed to go on forever.

Spanking

Materials needed:
Soap, washcloth, towel and bowl of warm water
Rabbit or other fur
Slipper or rubber shower clog
Wooden kitchen spoon

Susan laughed. "You've been a bad boy. It's time for your punishment." She pointed toward the floor, and with a practiced gesture, Bob sank to his knees.

His voice was low and subservient as he responded, "Yes, my love." He tried to hide the wide smile that kept breaking out on his face.

In a dramatic voice, Susan read the list of infractions Bob had committed during the previous week. They included putting too much milk into her morning coffee on Tuesday, blocking her car in the driveway with his on Thursday and failing to make the bed properly on Saturday. When she had finished, she paused and said, "Fifty spanks."

He could feel disappointment mixed with excitement as he looked at her feet. Fifty was less than he usually earned, but he didn't dare protest.

Many times skilled dominants will set up situations where the submissive may feel neglected [as in too few spanks for Bob] and then rectify the situation in a way that confirms and upholds the relationship.

"First," she said, sinking back into the reclining easy chair, "do my feet."

Bob rose quickly and went into the kitchen. He drew a bowl of warm water and got the soap, washcloth and towel from their accostomed place. He returned and took his place at her feet. Carefully he removed her shoes and began to wash her feet. He had only just touched her with the damp washcloth when she jerked away and leaped to her feet.

"The water is too cold; what are you trying to do to me, you clumsy fool?! That will bring the total to 100 spanks. Now, get back to the kitchen and bring out some warm water."

"That's better," she said, as he began again.

Slowly and carefully, Bob soaped and rubbed Susan's feet while she made little kittenish sounds of pleasure. He was particularly attentive at cleaning the very sensitive spots between the toes. Finally, he conscientiously rinsed both feet with clean water. When her feet were perfectly clean, he started to kiss them gently and, then, with increasing vigor and passion. Soon, he was sucking each toe individually, and she was gasping with pleasure.

After about five minutes, she lifted one foot and placed it gently against his forehead, pushing him away from the foot he was attending to. "That's enough," she said, huskily. "It's time."

Bob stood and unfastened his pants. At first, they refused to slide to the ground, being held in place largely by his enormous and almost painful erection. When they

finally gathered around his ankles, he made no move to step out of them. Instead, he shuffled, like a prisoner in leg irons, over to Susan's chair, where she was arranging a series of items on the table beside her. Bending forward from the waist, he lowered himself across her knees.

"Count," she said.

The first spank was gentle, almost tentative, and muffled a bit by Bob's cotton underpants.

"One," he said.

In steady progression, the spanks became firmer, more aggressive, and by the tenth one, he could feel the warmth rising in his backside. She never hit exactly the same place twice in a row and the glow seemed to be spread evenly across his buttocks.

"Fifteen." By now, he was gasping a bit, and the warmth had become a fire. Susan paused, and he could feel her lowering his underpants so his bare buttocks were exposed. She gently rubbed his ass and scraped it gently with her fingernails. He arched and moaned in pleasure.

The "fifty" was gasped out, and Bob was having trouble holding still on Susan's lap. He moaned and melted when, instead of her hand, he felt the sensual softness of fur. For about a minute, he wriggled as she explored the shape of his ass with the piece of rabbit fur.

When "fifty-one" arrived, Bob gave out an involuntary yip. Susan had stopped using her hand and was spanking him with an old slipper she had saved for that purpose. The worn leather sole contoured itself to the curves of his buttocks with each blow, covering a larger area than had been covered with her hand.

> Spanking, or any other discipline activity, should begin slowly so the submissive can adjust to it. As the excitement and the level of endorphins rise, the dominant can increase the intensity while carefully monitoring that the stimulation is not so intense that it distracts the submissive from the pleasure of the activity.

Mixing sensual breaks in any discipline activity intensifies the level of both and gives both parties a welcome respite.

This effect is far from uncommon although not all submissives experience it nor can those who do confidently expect to feel it during every scene. It is often referred to as "getting into the submissive space," "the float" or other terms. It is believed to be a combination of mindset and the effects of chemicals generated in the body by stimulation. Runners speak of much the same effect when they talk about "going through the wall."

By "seventy-five," he wasn't sure that he was still vocalizing the count. The fire in his ass had spread throughout his body and had transformed itself into something inexplicable. He felt as though he were in two places at the same time: firmly over his lover's knees and, at the same time, floating somehow in another space. Occasionally, he was vaguely aware of her pausing and caressing him, but most of his attention was focused inward.

At "ninety," he was blasted to a new level by a sudden increase in the intensity of the spanks. One small part of his mind remembered the long wooden spoon on the table. Ordinarily, he would have been unable to stand the intensity the hard wood produced and would have had to call his safe word, but in his present state, it was like supercharging an erotic engine. The room seemed to fade and he was totally tied up in the erotic ambience of the scene until, as from a distance, he heard his lover's voice.

"That was hard work; let's go to bed, and you can thank me properly."

Bob rose unsteadily and, supported by Susan, made his way toward the soft covers.

Discipline

Materials needed:
Cuffs and four-point attachments in walls or doorway
Belt or strap
Rabbit or other fur
Cat of nine tails
EMT or bandage scissors
Glass of wine
Straight razor
Safety razor

When Maryanne entered the room, she was both excited and a little frightened. Steve had told her on the phone they were going to take a step beyond their usual bondage and spanking, but he had refused to elaborate except for some cryptic instructions telling her to bring extra clothing. Without a word, he took her wrists and put them through leather cuffs, which were attached to thin nylon ropes coming down from high on opposing walls. He tightened the cuffs, rotating them so that the inside of her wrists were toward the attachment points, and tightened the ropes so her arms were pulled upward and apart. He repeated the process with her feet. In less than a minute,

The cuffs were rotated so that the pressure would be against the back of the wrist; the front contains blood vessels that could be blocked if the submissive fights against the bondage. It is important that the feet remain on the floor, as suspension introduces a whole series of additional complexities.

she was a human X held taut by four ropes. Her feet were firmly on the floor but she was unable to move.

"Fight the ropes," he said. "Fight them so you can feel how absolutely helpless you are."

She did, and a wave of passion rolled over her. She was helpless. What had been a word before now was a reality. She was helpless. She was a slave. He could do anything he wanted. What did he want? What? What?

"The bag in the living room," he said, "contains the extra clothing I told you to bring?" She nodded, not trusting herself to speak.

"Good," he said and took her blouse in both hands and ripped it from her breasts.

The violence of the maneuver, the sudden freedom of her breasts. Suddenly, it all became real. She was a sex slave; she was *his* sex slave. He was going to strip her, beat her and rape her. He was going to use her body for his pleasure and there was nothing that she could do about it.

Without his even touching her body, she came. Her eyes rolled back in her head, and she let out a low cry and felt her body explode.

When she recovered herself, she found him looking at her with that slow, amused smile, and she blushed. He really did own her now. Was he going to strip her completely now?

Evidently, that wasn't to be – yet.

He took a leather strap, about a foot long, from a nearby table and ran it over her exposed breasts. Her nipples, which had shrunk after the orgasm, sprang to

attention. She found herself trying to arch her back to keep the leather touching her, but he pulled it back – and snapped it hard onto the lower hemisphere of her left breast.

There were no words for what went on in her mind as the strap hit. There was pain, not much... but magnified by her helpless situation and by what was going on. However, the pain was quickly put aside by a wave of fire that spread from her breast and made a beeline for her pussy.

Before the shock of the blow could subside, she felt something warm and pleasant stroking her breast. When she looked down with surprise, she saw that he had a piece of fur and was rubbing it over the pale red rectangle the strap had left behind. The texture of the fur somehow mixed with and amplified the fire in her pussy. She closed her eyes and moaned.

The strap hit again, this time on the bottom of the right breast. She tensed, and then relaxed as fur stroked the hurt into something else.

The top of the right breast. The bottom of the right. Left. Left. Right. The fire grew. She could feel her nipples growing, her pelvis churning. Suddenly, he stopped and pulled her head back and kissed her – deeply and passionately. She strained to bring her body closer to him. She had never wanted anyone as badly as she wanted him now. His tongue was deep in her throat, and she tried to draw it deeper. Then, he was gone, and the fire raged higher. She looked around wildly. She felt his hands on the back of her blouse. With a rip, her back was as naked as her breasts.

She looked over her shoulder. He had taken a cat-of-nine-tails from the table. "Noooo," she moaned. But he

> Such a stroke should be relatively short and come only from the wrist. The breasts can be quite sensitive, particularly around menstruation, and should be stimulated with exceptional control.

A cat-of-nine tails, or flogger, is the whip of choice in the scene. As long as the "tails" are fairly broad and are not braided, knotted or weighted, the whipping can be much less brutal than it may seem. Again, initial whippings should be from the wrist so that the impact is limited. Using the shoulders and back muscles should be delayed until considerable skill at whipping is acquired. The whip should only strike the shoulders and ass. Considerable care should be used in avoiding the lower third of the back, where the vulnerable kidneys are close to the surface.

looked at her and smiled. Then, gently, he whipped the cat around and let its strands come to rest over her shoulder and breast. The leather felt so cool and soft as it slid across her skin as he drew it back. She could smell it: a sensual exciting smell overlaying the pungent aroma that filled the room. With a shock, she realized the source of that second, pervasive smell. It was coming from her. The odor of aroused woman was filling the room like a heady incense.

Again, the cat's tails caressed her breasts. She looked down and realized with shock that her nipples had never been larger. They looked like acorns... and they hurt with the need to feel a lover's fingers, a lover's teeth. Caught up in herself, she wasn't paying attention when he raised the cat and brought it down, hard, across her back.

The whip hit and she lurched forward, bringing further protests from her arms. "Eeeeeh," she gasped through clenched lips. Again, the pain wasn't anywhere as intense as she had expected, but it was the symbolism and the helplessness that were the turn-ons. He used the momentum of the whip to bring it around and again a sensual fire blossomed across her back. Three more times the whip fell, and Maryanne's breath came in gasps.

I can't take any more, she thought. But the fire across her back was matched by the one between her legs. She realized what she had felt earlier was just a pale precursor of the lust that now held her in its grip. As suddenly as he had begun, he tossed aside the whip and, reaching around her, pinched her aching nipples. She arched her neck and felt his lips on hers and his tongue again driving down her throat.

I'm being tongue raped, she thought, *and loving it!*

He removed his lips from hers, but with one hand on her hair, held her in that position. She felt his lips on her neck and, then, his teeth, biting down hard. She screamed, half in passion, half in pain. She thought that he must have drawn blood.

He released her hair and circled her bound frame until he was standing in front of her, a pair of oddly shaped scissors in his hand. One blade was conventional; the other had a spoon-shaped attachment that puzzled her until he slipped the concave blade through her waistband and neatly cut it open. Taking one side of the cut in each hand, he ripped her skirt from her body. He had told her on the phone not to wear anything that she ever wanted to see again. She had assumed that he was going to keep her clothing as a souvenir. Now he was using it to drive her mad. Mad. *Yes, I'm going mad,* she thought. *I can feel it. It is sooo sensual.*

> The scissors are called EMT scissors. They are designed so that medics can safely cut clothing, including boots and belts, off victims who may be struggling.

Her skirt dropped to the floor at her feet, and she felt the coolness of the blade against her pubic mound inside her panties. Snip. It moved. Snip. And again it moved. She waited for the ripping sound and nakedness. Waited, and waited. Surprised, she opened her eyes and saw him standing, hands on hips looking at her and smiling. "You still don't realize," he said, "what happens, happens when I want it to happen. You are a slave. You exist for my pleasure." She could feel little shocks of pleasure in her pussy with each of his words. He knows; he understands.

> "Slave" can be a very loaded word for people. Some find it intensely exciting; others are repulsed by it. The use of such a term should be part of any pre-scene negotiation.

She felt his hands on her breasts again. She arched, and he bent his head and began sucking on her nipples.

They burned and felt the size of bowling balls. Her mind began to float and drift.

Suddenly, agony shot from her breast. He had bitten down, hard. She twisted and turned to get away from the pain. Or did she? Maryanne was horrified to realize that she was arching her body *toward* him. As she recognized the betrayal of her body, it was shaken by an explosive orgasm. For the first time in her life, an orgasm made her scream at the top of her lungs. The spasms went on for what seemed like an eternity. Every time she began to come down, the pinioning of her arms and legs would trigger another spasm.

Finally they subsided, and she hung exhausted from the ropes, panting. He looked at her, turned and walked away into the small kitchen just off the bedroom. She was too exhausted to wonder. She was too exhausted to do much of anything except hang from the ropes and bask in the afterglow that seemed to surround her body. Then, he was back, a glass of white wine in his hand.

The use of alcohol in a scene should be prenegotiated. Some submissives prefer not to play with a dominant who's been drinking even a tiny bit, and others may have health or personal issues with alcohol.

At that moment, she realized that she was thirstier than she had ever been. Some sort of perverse instinct made her voice low and pleading as she said, "Master, may I have a drink? Just a small one. Please."

He smiled and drained the glass into his mouth. Before she could react, he reached behind her, pulling her hair, bending her head back. Without thinking, she opened her mouth, and he covered it with his... and allowed the cool fluid to drain into her mouth, filling it and spilling over her neck and breasts.

Sooo sensual, she thought. *Everything is so sensual.*

"You are messy," he said. "I guess I'll have to clean you up." And began to lick the wine off her body with long loving strokes of his tongue. She had thought she was too satiated to have any desire. She would have sworn to it. She would have been wrong.

The desire welled up in her as if she hadn't just come countless times in the last five minutes. Her hips began to move of their own accord as they sought something hard to fill her spasming cunt. He looked down at her panties and casually ripped away the last piece of clothing that covered what was left of her modesty.

"You have a hairy pussy; I'll have to deal with that." Steve turned and walked into the bathroom, returning with a can of shaving cream and... *Christ!*, she thought, *it's a straight razor. He can't be planning to use that on me*, she prayed.

As had happened so many times before, she was wrong... so very wrong.

The foam was warm and sexy against her cunt mound, and she had another orgasm while he was completely coating her lips with it. She couldn't take her eyes off the five inches of gleaming steel. *It's razor sharp*, she thought, then giggled to herself; *of course, silly, it has to be; it IS a razor.* Even when he blindfolded her, she could still see that razor.

She held herself rigid as the blade sliced away the hair on her mound and quested between her legs. If she hadn't already had more orgasms that evening than she had

The blindfolding is necessary because the straight razor is only a prop. Using such a tool, even on a completely immobile person, is quite difficult. As soon as the submissive's eyes are covered, a conventional safety razor is substituted.

had in all of her life, she was sure that the feeling of the sharp steel on her pussy lips would have caused her to explode. As it was, she held off until she felt the steel move away from her.

The orgasm shook her the way a terrier shakes a rat.

"Still too hairy," he pronounced. She could hear him dispensing more cream into his hand. For a moment, she didn't realize what he was going to do. The man is so unpredictable; I love it. He began to slather the cream on the back of her neck, her breasts, her neck. Slowly, sensually, he covered her body with the warm, white lotion.

With abrupt, businesslike strokes, he removed the cream and the minute hairs that had gone unnoticed until this second. Somehow the image she had of the blade wasn't frightening, even when it carefully removed the ring of hairs that had almost invisibly decorated the base of her nipples or the down that led upward from the crack of her ass. She recognized that this man could hurt her – he could, and would, twist her body with the agony that she had learned she needed, but she would never come to unintentional harm while she was in his hands. With that realization, she relaxed and enjoyed the massage of the blade.

The Waxing

Materials Needed:
Scarf or blindfold
Massage oil
5/16" or larger nylon rope
Paraffin candles
Dental dam
Nipple clips

It had been a long day at work, and Dianna was looking forward to relaxing with Melanie, her lover. But when she pulled into the driveway, she muttered a soft curse; the house looked completely dark. Mel must have gone out, she thought. However, when she walked through the front door, a hand touched the back of her neck and a familiar voice said, "Don't turn around."

Dianna felt her body react and ready itself. This was to be one of *those* nights. A scarf was pulled over her eyes, blocking out even the pale glimmers of light from the outside street lamps.

"Come with me," Melanie said, taking Dianna's hand. To her surprise, the warm, guiding hand led her down the

> Cutting off a submissive's sense of sight both intensifies the other senses and creates an air of delicious apprehension about what will come next.

hallway into the living room instead of to the bedroom they shared. Wordlessly, the hands guided her into a particular position, then vanished. In the background, Paganini's *Romanza* began to play. Dianna waited, impatiently shifting from foot to foot. The music began to affect her, and in only a few seconds, she found herself drifting into a haze.

If Melanie's voice had been any louder, it would have been jarring, so lost in the music had Dianna become. However, it was a soft whisper, just enough to carry.

"Take your clothes off."

Dianna's hands flew to the buttons of her blouse.

This time the voice was a bit louder and the hoarseness of controlled passion was audible – as was the note of command. "Not like that! Slowly, sensually, make me desire your body."

Dianna froze for a moment to shiver in delicious anticipation and, then, she began, slowly, as Melanie had commanded. She could feel goosebumps rising on her skin as each new area of flesh was exposed to the air. It wasn't really cool in the room, but the casual current of air reminded her of her nakedness – and of what would probably follow. A scent of roses – and of two excited women – filled the room.

Dianna removed all her outer clothing first, knowing that Melanie liked to see her in the expensive, frilly undergarments she gave Dianna as gifts on the slightest pretext. Knowing her lover savored seeing her like this, she raised her hands above her head and slowly pirouetted.

She was rewarded by an almost inaudible hiss of passion from the darkness beyond the blindfold.

Orienting herself to the sound, she opened the clasp that held the elastic cups of her bra, but her fingers, made clumsy by passion, slipped and the sections of the bra flew apart. The clip struck her full on the nipple. Surprise magnified both the pain and her erotic response to it. She gasped and felt the room seem to spin around her. In what seemed like only a fraction of a second, she felt Melanie's arms around her, steadying her, protecting her from the violence of her reaction.

As she regained her equilibrium, she felt a hand drift down over her silken panties and between her legs. The laugh was amused and superior. "My, aren't we the horny bitch today. I haven't even started and you are ready for anything. I bet if I gave you a cactus plant, you'd try to fuck yourself with it."

Dianna's face burned with embarrassment. She knew that she was willing to do anything to deal with the desire that enveloped her each time she and Melanie played.

Before she could react further, both the steadying hand on her waist and the teasing one at her pussy vanished, and Melanie's voice said, "Continue; show me all of your beauty."

Dianna finished her strip and stepped back into the high-heeled shoes she had been wearing. She knew that Melanie loved the effect that they had on her thighs and ass. Without being told, she took her breasts in her hands and held them as offerings to her lover.

It isn't enough that a dominant be aware of everything that he or she is doing. Submissives place their bodies in our hands; we must be aware of everything that is going on around them so as to be able to protect them from even themselves.

Humiliation can be more hurtful than physical discipline. It isn't something that should be used casually and requires a complete knowledge of the submissive's "hot buttons" and turn-ons.

"Hold your hands out in front of you," Melanie said, and Dianna found her fingers being dipped into something thick and warm. "Caress yourself; treat your body as you would treat mine. Show me what you could do for me."

Dianna touched her breast and realized that the liquid was warm massage oil. Slowly, she drew ever-tightening circles around her nipples, teasing herself until her hands were shaking in a tug-of-war between desire and willpower. Eventually, the desire won and her slick fingers closed tightly on the aching rosebud. Despite being ready for her reaction this time, she staggered. Again, the hands were there, but this time they guided her down and back until she was lying on what she recognized as the long oak coffee table she and Melanie had bought together.

The surface under her was soft and a bit warm. She guessed that Melanie had covered it ahead of time with a blanket. The hands guided her until she was lying full on the table with her lower legs and feet on either side. Melanie removed the blindfold, and for a moment, Dianna could only see her, naked, bending forward over her, breasts free and unbound inches from Dianna's lips. Instinctively, she arched to take one into her mouth, but was firmly pushed back onto the table.

Hungrily, Dianna stared at her lover, more beautiful than ever in the light from at least a dozen candles spotted about the room. The blindfold had made her eyes so sensitive that even this pale light seemed blindingly bright – or was it the glow from Melanie?

"No, my darling; at least, not yet," Melanie said with a wide smile. She poured some of the warm oil onto Dianna's

> If you are using furniture as part of your games, make sure that it is sturdy enough to support safely at least four or five times the weight you expect to put on it. Artificial board (fiberboard) easily fractures under strain, and things made from it should not be used for play.

stomach, making a pool over her belly button. She took Dianna's right hand and dipped it into the oil. "Pleasure yourself; I want to watch." Her smile grew even wider, "But don't let yourself come. If you do, I will make you regret it."

Dianna didn't know if she could even touch herself now. She felt like a coiled spring waiting for the gentlest touch to send her flying into another world. She began tentatively touching her inner thigh with the oiled fingertips, lazily tracing patterns on the soft skin. Unbidden, her other hand dipped in the oil and echoed its partner's travels on the other thigh.

Her breasts called, and her right hand drifted through the oil, leaving a warm track in its wake as it negotiated the slopes of her desire. Soon she was lost in it. Fingertips forgotten, she palmed dollops of oil over her body. Wordlessly, Melanie added new oil as the original reservoir was depleted.

Gasping in passion, Dianna looked down the length of her body, now glistening with oil, the candlelight creating highlights and dancing shadows. She had never seen herself like this; was this what Melanie saw? The spring wound tighter. She felt her self-control fraying like aged cotton.

"Please, darling, may I come?" she begged, her voice gravelly with passion and need. "May I come, *now?*" The last word was a gasped scream — a scream that became one of frustration when Melanie took first one wrist and, then, the other and slid them through loops in a rope that

Leather cuffs are the safest form of bondage, but ropes are sufficient to hold someone still if the knots are tied carefully so as not to tighten on a limb and care is taken to avoid cutting off blood supplies or pressing on nerves.

ran under the table; a moment later, her feet were also securely bound.

The happiness that being in bondage always brought her warred with the unslaked desire boiling between her legs. She gritted her teeth and vowed to come, but the delicious desire remained at a simmer, frustratingly short of the rolling boil she ached for. A change in the pattern of light and shadow falling on her brought her back from her efforts.

Melanie was approaching, a candle held in each hand. Unlike the slim beeswax tapers lighting the room, these were squat, white paraffin candles. Dianna knew instantly what she intended to do and her eyes went wide. "Nooooooo!" she gasped. But Melanie only smiled and sat on the edge of the table, holding the candles high in the air and beginning to tip them to spill the molten wax on to Dianna's waiting skin.

Dianna's eyes flicked from side to side as she tried to watch both candles at the same time. The light held her enthralled. The twin masses of melted wax fell away from their respective candles simultaneously and seemed to fall in slow motion toward her legs. When they hit, the sensation was like flaming needles. As the wax cooled, it tightened over the skin, hugging it, claiming it. Almost immediately, two more drops fell, striking only an inch or two from the first. Dianna closed her eyes and let the sensation enfold her.

She twitched and cried out as the two lines of wax marched up, weaving back and forth across her belly and

up the slopes of her engorged breasts. Just short of the nipples, they changed course and marched out again along her collarbone and down her arms. The drumbeat of stimulation halted, and an almost electric shock of pleasure caused Dianna to cry out. She opened her eyes to see Melanie's mouth teasing and playing with her left nipple; teasingly, she dragged her long hair across Dianna's chest before artfully tossing the dark mass over her shoulder and feasting hungrily on the other nipple.

Dianna threw her head back and arched at the flood of pleasure. She was still arching when Melanie released the nipple from her lips and allowed a single drop of hot wax to fall directly on the tumescent bud.

Dianna screamed as the eroticism became too much to stand. The orgasm that had been waiting in the wings of her soul took possession of her.

Melanie watched the shaking, screaming woman for a few moments, gauging the intensity of her sensation. As soon as the tide of passion began to recede, she lowered both candles within in a foot of Dianna's breasts and inverted them so that a steady stream of wax fell on both nipples. Within a few seconds, the young woman was again gripped by an orgasm – only this one went on and on and on. Each one setting the stage for the next until the streams of wax were falling, not onto naked flesh but onto a solid mass of hardening paraffin.

Only when Dianna lay gasping, exhausted, did Melanie blow out and put aside the candles. Kissing her lover's mouth, she said quietly, "Now, it is your turn to pleasure

> Waxing can be an incredibly sensual activity. However, beeswax melts at too high a temperature to be used safely. Colored candles contain dyes that may irritate a submissive's skin. (You can test this with one or two drops.) The safest and best way to begin is to use cheap white candles. Height is another factor that controls the temperature of the candle wax. It cools rapidly as it falls, so waxings should begin with the candles held at least three feet from the submissive.

Contrast is an essential element of D&S. Submission by a strong person is infinitely more pleasing and powerful than that of a weak one. "Pain" unpaired with pleasure becomes dull and uninteresting. By mixing sensations, the dominant can help the submissive fly all the higher.

me." Kneeling over Dianna's mouth, she stretched a dental dam over her pussy and lowered it to where the bound woman waited to reward her loving dominant for a job well done.

The Picnic

Materials needed:
Sensual food
Screw-in dog-tether
Hairbrush
Birch branches
Plastic dog bone

The picnic was lovely. The hot spell had broken just the day before, and the air was cool and comfortable. From the top of "their" hill, Brett could watch the barges moving in stately procession up and down the Mississippi only a mile or so away. It was a wonderful spot that she and Daniel had discovered only six months before while exploring on his motorcycle. Swamps at the base of the hill and a heavy growth of birch trees on the far side provided a degree of privacy she would have thought unthinkable only a few hundred yards from a narrow dirt road.

As they laid out the pate and chilled chicken, tiny jars of caviar and smoked salmon, Daniel smiled mysteriously and said, "Eat lightly, my dear. I don't want you stuffed later." Brett had looked curiously at the single small bag that he had pointedly set apart from the others, but kept her silence.

Overeating prior to a scene is a very bad idea. Not only does the logy feeling from a full stomach interfere with the enjoyment of the sensations. The intense physical responses can bring on nausea – not an aesthetic feeling at any time, but highly dangerous when one is bound and gagged.

As the meal progressed, their passion had climbed. Daniel's exploring hands had progressively stripped off much of her clothing. Naked to the waist, Brett lay back on the linen sheet while Daniel spread paté and caviar onto her breasts and belly before licking them off. He took off his shirt and lightly rubbed his upper body against hers, then, spooned on some more caviar. She gasped as the cool caviar covered one nipple. Daniel took the full breast in one hand and lifted her head with the other. With gentle pressure, he brought them together until Brett could extend her tongue to taste the delicious caviar made all the more flavorful by the seasoning from her body.

It is so exciting, she thought as the touch of her tongue controlled by her lover made her muscles clench with pleasure. *He is so sensual.*

As she lay back, breathing hard, Daniel tugged free the rest of her clothing. Sighing with pleasure, Brett spread her arms and legs, welcoming the gentle sun. She felt both excited and calm, a state that seemed to resolve itself without effort on her part. She heard a jar opening and, looking over, saw Daniel opening a jar of cherries. He took one in his mouth and holding it between his teeth, offered it to her with a kiss. The sweet juices of the cherry mixed with the greater sweetness of the kiss.

He took another cherry from the jar but held it between his thumb and forefinger while he moved down to the space between her outstretched legs. His eyes held hers while he slid it between her pussy lips and deep into her pussy. The feeling was so intense that Brett had to break the eye contact and arch her back. When she looked back,

Introducing items, particularly those containing sugar, into the vagina can set the stage for yeast infections. This risk can be lessened, but not removed, by a medicinal douche following the activity.

he was leaning forward. The first touch of his lips on her pussy was gentle, almost tentative.

However, it soon became clear that he was determined to regain the "lost" fruit using only his tongue and lips. Brett began to moan and twist. One hand, off the sheet, ripped a handful of turf from the ground while the other gripped the sheet with such fervor that the wine bottle toppled over on its side and the silverware danced noisily on the serving plates.

Knowing how sound carried in the still air near the river, Brett tried to control the screams of passion that threatened to break out of her throat, but this just made her need all the more pressing. Finally, Daniel made one final, deep lunge and she lost all control. The waves of passion engulfed the final citadel of her control, and she gave out sort of a bark, sharp and short, and fell back gasping. When she could reopen her eyes, the first thing she saw was Daniel leaning over her, eyes sparkling, a bright red cherry firmly between his teeth. He leaned forward. This time the cherry was triply flavored, including the sweet muskiness of her own scent.

As they lay together, the light breezes and the sun dried the sweat from both their bodies. Daniel said, too casually "I bought a few things at the pet store yesterday." Brett looked at him curiously but didn't speak. He got up quietly and, opening the mysterious bag, dumped the contents out on the ground. A profusion of straps, collars, brushes and other items fell out. As Brett pulled herself into a sitting position, Daniel took what looked like four giant corkscrews

Unprotected cunnilingus may contain the risk of STD transmission. The risk seems to be much less than with some other forms of sex, but those taking part in such activities should be aware that this risk may exist.

and walked a few feet out onto the grass. There, he screwed each one solidly into the ground, forming a rough rectangle about four feet by six.

After screwing the last one deep into the rich topsoil and giving it an experimental yank, he looked over to Brett. "These are supposed to keep little puppies from running away; I thought they might serve the same purpose for little women."

The words erased any confusion from Brett's mind, and she felt her nipples tighten with excitement. With no surprise and growing anticipation, she watched Daniel pick up four small nylon dog collars and approach her. Without being asked, she held out her hands so that he could fasten two of them in place. The other collars went around her delicate ankles. Four leashes completed the arrangement.

Daniel had her kneel, then lie face down between the four metal loops that projected above the ground. He attached one leash to each loop, holding her immobile, spreadeagled. She closed her eyes and breathed in the warm scent of the ground, the tang of chlorophyll and the perfume of the wildflowers. As always, the bondage made her feel safe and secure. Perversely, it allowed her to feel a freedom she could never feel unbound. Outside the ropes, she had inescapable duties and responsibilities. Tied, she was free to feel and to experience without accountability.

She tugged a bit, confirmed her helplessness, and sighed in happiness.

She felt a motion and opened her eyes to see a pet brush Daniel was holding down in her range of vision. He

Except when absolutely no struggling is expected, wrists should not be tied with anything more narrow than half an inch – and two inches is much safer. Narrow bonds can cut off circulation and may result in nerve damage.

held it in her view for a moment, running the bristles over the palm of his hand before running it over her back. The scratching sent an ecstatic shiver through her body. He started lightly and, as she became accustomed to the feeling, pressed harder and harder.

After perhaps a minute of this, he began to pat rather than stroke her ass. Again, it began lightly, but quickly built up to the point where she was moaning and gasping. The initial sensation was of being spanked with a thousand tiny needles, but the individual sensations soon merged into a stinging fire. The fire spread to her pussy and made her try to grind it against the soft earth, and some part of her realized, it was making her move in a very salacious manner. That only made her hotter.

As she moved, she felt another sensation mixed with the spanking. Evidently, Daniel was holding the pet brush in one hand and playing with her pussy with the other. This was unbearable. The sensations rushed over her and she pressed her mouth onto the grass so she could give vent to a full-fledged scream.

When the orgasm receded, she noticed that the spanking had fallen off to a pattern of light taps with the bristles and, then, stopped altogether. She made her voice low and submissive. "May I be released now, sir?" she asked.

"Not yet, darling. We have barely begun," Daniel replied. He went over to the picnic area, picked up the neatly folded blanket that they had brought with them, and spread it out over her. With a vague sense of surprise, Brett realized that she had been a bit chilly despite the warm sun.

Most stimulations should start gently to allow the submissive to build up a level of excitement and begin to produce endorphins. Beginning at too high a level may set up a situation where the submissive can never "catch up."

Exhibitionism is often part of submissives' fantasies. For these people, being forced to behave in overtly sexual ways isn't humiliation; it is the fulfillment of a long-held dream.

Many people become slightly chilled after an orgasm, so some sort of covering should be available. The dominant's duty is to be more aware of the submissive's needs than he or she is. During a scene, submissives are often disorganized and distracted. They have given us their power; it is up to us to make sure that they are kept safe.

Safewords allow the illusion of non-consensuality. The submissive can cry, beg, or protest without interrupting the flow of the scene. However, he or she can stop the scene instantly in the event of a real emergency.

Drowsiness competed with curiosity, as Brett watched Daniel walk to a nearby stand of birches and begin to trim some branches with a small clipper. Suddenly, she wasn't drowsy any more.

"You're *not!*" she cried.

Daniel didn't even turn around and continued selecting branches the way a florist selects flowers for a bouquet.

"Please, that will *hurt!*" Brett begged.

Finished, Daniel came over and knelt down next to her. "I guess it will," he said. "Do you want to use your safeword?"

Brett almost snarled in frustration. He had neatly thrust the decision back onto her. All she had to say was "red light" and the scene would be over. He wouldn't birch her. Nothing more would be said about it, but she would always wonder what it would have felt like.

She made a low growl in the back of her throat as she reached her decision. Turning her face to the ground so she couldn't see the grin she knew would spread across Daniel's face she said, "Please don't birch me. I couldn't stand it," knowing full well that she had given him full permission to begin. Despite the coolness of the earth, she could feel a red flush spreading over her face and shoulders.

Brett felt Daniel draw his bunch of birch branches across her ass. The scratching felt good. She shuddered in pleasure and anticipatory fear. The first stroke was gentle, hardly more than a tap. Even tied as she was, Brett felt her body reaching up, longingly, to receive the next stroke. The

next one was harder, the one after that harder yet. She inhaled, every sense sharpened. The odors around her seemed as strong as incense. The colors were sharper and more concentrated. A particularly sharp blow on the underside of her ass seemed to shoot right through her and she ground her pussy against the sun-warmed soil. *It hurts sooo good,* she thought.

Now, the sharpness seemed to fade from things around her. Even the impacts of the birch bundle seemed somehow distant. She felt as if her body were light as a feather and would float away with each breeze. She was vaguely aware of Daniel stopping and the feeling of soft touches on her ass as he gently stroked the area. Although the touches didn't seem important – little did – she realized that the sensuality of the touch was freeing her more and more from the world around her.

When the next stroke came, Brett screamed. Immediately, something soft and yielding was slipped into her mouth and a cord tied around the back of her head. She longed for the next impact and was a bit annoyed when Daniel put his mouth next to her ear and said, "Do you remember your safe signal?" She nodded violently in frustration. *Why is he fucking around with this? Hit me again, you teasing bastard!* she thought. But he was stubborn. "Show it to me," he said insistently.

Brett groaned with frustration, but opened and closed her hands rapidly. She greeted the next blow as if it were a long-lost lover, and even the gag did little to silence the scream of joy.

A birching tool consists of a bundle made up of handful of small branches, from one to three feet in length, bound into a compact bundle. Trim the ends so all the branches end at the same place to maximize control. Branching twigs should be cut off as close to the main stem as possible.

A pause at this point is important for two reasons. First, ecstasy is reached best by a zigzag route. Mixing soft simulation with hard increases the effectiveness of both. Second, after a few minutes, the ends of the birch package would be breaking off and it would need to be trimmed.

A person *must* have a safe signal if he or she is unable to vocalize a safe word. It is also a good idea to check occasionally that the submissive is not so far into "the float" that the safeword or safe signal has been forgotten. (The "gag" that Brett had in her mouth was a plastic "doggie bone" from the pet store Daniel had visited. He had simply run a cord through its hollow interior and tied it around Brett's head.)

Each succeeding blow drove her higher and higher until she was lost in a wonderful relaxing haze. Somewhere, she was eventually aware that Brett was rubbing a cooling lotion into her ass, and then was untying her. As he lay down next to her, she drifted from the haze into a deeper sleep.

When she awoke, he rolled her up on him and they gently moved together until it was Daniel who cried out.

The Cocoon

Materials needed:
Plastic wrap
Ice
Orange juice or other drink
Bandage scissors
Condom

The delicious odor of Shrimp Gumbo drifted into the bedroom and awakened Jeff. He luxuriated in the warm sheets for a moment and rose, putting on a flannel robe before padding into the kitchen were Philippa was humming over a slowly bubbling pot.

Grabbing her around the waist, he lightly bit her neck. She gave a small scream and dropped the spoon she was using into the pot.

Wiggling against him, she said, "That was naughty. You're going to have to be punished for it."

At her words, Jeff could feel himself hardening against her tight buttocks. Obviously, she also felt the physical indications of his growing excitement because she turned in his arms and reached down to grasp the "evidence" firmly.

"And that," she said, "is going to be part of the punishment."

With a brushing motion, Philippa pushed the collar of the robe over his shoulders until it dropped onto his upraised forearms. Without being told, Jeff lowered his arms so that it fell the rest of the way to the floor. Standing naked, he lowered his eyes and waited passively for his lover's next order.

She turned around, lowered the heat under the pot and turned back to give him a slow appraisal. Nodding, as if she were looking at his body for the first time, she said, mostly to herself, "Not bad, not bad at all," then, a bit louder, "Put your hands behind your neck."

With the tips of her fingertips, she caressed his nipples, smiling slightly as they grew harder and firmer. When she judged the moment right, she bent forward and bit firmly on each in turn. Jeff bit his lip and the interlocked fingers of his hands writhed, but he didn't move.

"Hmm," she said, "you look good enough to eat." An extra sparkle lit her eyes. "But, I wouldn't want you to get spoiled." She looked around the kitchen and said, "Go into the bedroom, kneel in the corner and wait for me."

It may have been five minutes, a half hour, even an hour before Philippa came into the bedroom with a shopping bag. Jeff had no way of knowing. Waiting in the corner always did this to him. With nothing to look at but the blank walls and with a raging erection providing a continuous reminder of why he was waiting, he would slip into a contemplative state during which time had little meaning.

"Stand up and come over here," she said from next to the bed. When he was standing facing her, she said, "Put

Men's nipples may be smaller and a bit less sensitive than most women's; however, they are still an erogenous zone and worthy of significant attention.

Sensory deprivation does not always mean blindfolds and ear plugs. Just staring at a wall for a long period of time can release the mind to a much greater degree than most people would realize.

your arms straight out in front of you. Good. Now bend them and touch your elbows together." Standing in front of her like a Russian dancer, Jeff found his anxiety giving way to puzzlement. However, this vanished when she took a roll of plastic wrap from the shopping bag and wrapped his forearms together.

Giving the roll a dexterous flip, she wrapped his upper arms until it looked like he had a silver rectangle projecting horizontally from his shoulders. Ordering him to lower his arms, she wrapped the packaged arms tightly against his chest by repeatedly running the wrap over the arms and around his back. Philippa had placed Jeff in bondage before, but the plastic wrap was new. Experimentally, he tried to move his arms and found that he was incapable of moving them more than a fraction of an inch. He found that he could just about wiggle his shoulders, but any other motion was impossible. This was a confinement orders of magnitude more intense than any he had experienced before.

The compression around his chest should have seemed frightening; instead, it was comforting. He felt as if he were being hugged all over. The feeling increased as she ran several loops over his buttocks and between his legs, trapping his cock tightly against his body. He expected her to continue to wrap his legs until he looked like a big silver mummy. Instead she left the roll hanging, bouncing a bit against his leg as she got some wide packing tape from the bag. She ran six overlapping strips from the wrap, covering his stomach, over his shoulders and down onto his ass. He looked down and admired how the three strips over each shoulder formed a nice V over his front.

A person with his or her legs held together is very unstable. Leg bondage should be the last thing on and the first off.

If a person cannot move, the heart will have difficulty pumping blood to the brain. Dizziness and, possibly, unconsciousness will result. No one should be left in standing bondage for an extended period of time regardless of whether they are supported or not.

Fear, as well as physical stimulation, results in the production of endorphins.

Starting just under his collarbone, Philippa made a continuous spiral of tape around his chest down to below his waist. Only after he had been firmly taped into his plastic straitjacket did she return to wrapping his legs together.

When she finally cut the streamer of plastic wrap, the only parts of Jeff's body open to the air were his head and feet. The wrap had initially felt cool against his skin, but it warmed quickly, and soon, his only sense was of compression and restraint. There was none of the localized pressure and chafing that came from ropes or cuffs.

Almost immediately he began to feel dizzy. Philippa looked at him for a moment and with a wide smile, put her hand in the middle of his chest and pushed. For a moment, he felt a wild panic. Unthinkingly, he fought against the plastic to extend a hand to break his fall, but it held him firm. Then, he collided with the soft support of the mattress.

As the panic left him, Jeff felt a wave of euphoria. It made his head spin even more than the bondage.

With a businesslike humming, Philippa lifted his joined legs and completed the taping. Flipping him over on his stomach, she took a long wooden spoon out of the shopping bag.

"Naughty boy, you made me drop a spoon. I think this is very appropriate," she said, as she brought it down sharply on his ass.

Jeff let out a yell. He had thought that the wrapping might serve to muffle the spanking that he knew he was going to get, but instead, the compression seemed to make the blow sting even more.

Philippa sat on the side of the bed and cocked her head like a cook judging how well a particular dish was cooking. "Hmm," she said, "on a scale of one to ten, where ten is your safeword, what would you say that was?"

For just a moment, Jeff thought about saying "ten," but he repressed the puckish humor and thoughtfully considered the intensity. "May I have another just like it," he said finally.

"Greedy," she said, smiling indulgently, but brought back her hand and delivered an identical whack to the other side.

"Six," he responded without hesitation. "Six."

The next three whacks were more gentle, and Jeff could feel the sting transmuting itself. As the spanking continued, he discovered that the plastic wrap made him intensely aware of his erection. While his ass was being heated by the obdurate paddle, his belly was burning with what felt like a rod of blistering iron pressed against it. Soon, he was crying and begging, something both he and Philippa found intensely arousing.

He was vaguely aware that she had stopped striking him, but was too far into his own space to open his eyes and watch what she did next... so when the icy cold penetrated the wrap it came as a complete surprise.

"Ahhhhhh," he moaned, looking around wildly. Without saying anything, Philippa moved a gloved hand to where he could see it. The glove was full of finely crushed ice. She returned it to his ass. At first, the coolness was almost pleasant against the blaze that the spoon had ignited. But, the chill became intense. The cold became teeth biting

> Feedback in a scene is often informal and non-verbal, but there is nothing wrong with asking a submissive about his or her feelings. Although no dominant should ever use a tool that he or she has not felt personally, circumstances like position and bondage may intensify stimulation.

into his flesh. He was again surprised at how little protection the layer upon layer of plastic provided. It seemed that its only purpose was to hold him immobile, a task it was performing to perfection.

He tried to fight it, but the cold struck at a part of his soul around which he had erected few defenses. In less than a minute, he was again begging and promising her "anything" if she would just take it away. Unmoved she let him babble for a time before removing the ice but, before he could enjoy the return of warmth to the frigid flesh, began again with the spoon. Its impact seemed to be magnified by the lingering chill.

Twice more, Philippa stopped and treated Jeff to a chilling reprieve. Finally, she rolled him on his back. He tried to arch himself to keep his stinging ass off the bed, but she pushed him down firmly. "Thirsty?" she said.

Jeff was surprised to hear a soft croak when he attempted to answer. It was with a bit of a shock that he realized that his mouth felt as though it had been stuffed with cotton. Philippa smiled and took a small bottle of orange juice out of the bag. However, instead of holding it to his mouth, she drank deeply from the bottle, put it aside and bent down to kiss him. As his mouth opened automatically to receive the kiss, he was startled to taste orange juice transferring from her mouth to his.

The orange juice brought a new alertness. Jeff was startled to discover how alive he felt. He wondered if Philippa had planned something more. He froze. Only his eyeballs moved as he watched her bring the bright silver scissors close to the hump his erect cock made in the cocoon.

Submissives use a lot of energy and sweat a lot. This needs to be replaced or they will be unable to enjoy the scene to its fullest. Small pieces of candy and sugared drinks should be kept available for use regularly throughout the scene.

He could imagine the sharp point of the scissors cutting into that most personal of organs and felt it begin to shrink as if trying to hide from the steel. Undeterred, Philippa slid one blade under a fold of plastic and with an audible "snip" cut it.

Slowly, carefully, she cut around the now slack cock until she could extract it with her fingertips. Bending down, she bestowed a gentle kiss on its tip and began to caress it gently. Quickly, it regained its former stature. Giving it another quick kiss, she removed a condom and a candle from the shopping bag.

Making sure that Jeff was watching her, she put the condom in her mouth so that the tip was against her tongue and the rolled portion was between her lips and her teeth; conscientiously, with a lot of teasing and play, she slid it over his cock without using her hands.

Jeff knew he was close to losing it. He closed his eyes and concentrated on self-control so he missed seeing Philippa light the candle and poise herself next to him. His first warning was a slight shift to the bed and suddenly he was engulfed in woman. Her heat penetrated the condom in a flash and he felt himself about to release a flow of fiery magma.

However, the real fire blossomed on his chest instead of his groin. Jeff's eyes flew open. The first thing he saw was his lover, magnificent in her nudity sitting astride his cock. And, then, he saw the candle in her hand just as she upended it again so that the hot wax fell on the middle of his chest. He screamed, both in pain and frustration.

> Unnoticed by Jeff, Philippa was using a pair of bandage scissors. Like their bigger counterpart, the EMT scissors, bandage scissors have one blunt-ended blade that is safe to use near skin.

> Who says that putting on a condom has to be a clinical, anti-erotic exercise?

"Now that I have your attention, darling. I want to point out that I've been working very hard, and I deserve an orgasm. Since you don't seem to be willing to wait for me, I'm going to 'distract' you a bit until I'm finished."

With that, she began an up and down motion on his cock, riding him at a slow canter. The flickering flame of the candle was all he needed to keep under control until she shifted to a trot, and he felt the knot in his balls begin to tighten. He closed his eyes and reveled in the friction of her body against his. He felt himself tighten and... fire blossomed on his chest again, causing that tightening knot to vanish.

He swore that he wouldn't lose control, that he would pleasure his lover – or at least allow her to pleasure herself – as never before, but soon he was drifting away... only to be returned to reality by the fierce wax, against his stomach.

The trot became a full-fledged gallop. Holding on to the ragged shreds of his self-control by staring at the candle and imagining the heat of its wax, Jeff kept himself from coming. She was amazing, hair flying, breasts bouncing with abandon. He forgot about the candle until she brought it close to her and he braced for another scalding splash.

Instead she blew the candle out, threw it to one side and screamed, falling forward on his chest and hugging his plastic-wrapped body to her.

Later, as she used the bandage scissors to cut the cocoon from his body, he felt reborn into a new world of freedom and sensuality.

Because plastic wrap prevents the pores from breathing, a plastic cocoon should only be left on for a few hours and should not be used at all in hot weather or with people who have heart ailments.

The Kidnapping

Materials needed:
Pillowcase
Mask
Towel
5/16" or thicker nylon rope
Knife
Rope whip
Clothespins and string

Randy was nervous as she walked in the park. Her off-the-shoulder peasant blouse and short skirt were so different from her usual attire. She was also excited. She and Oliver had planned this scene for more than a month. It had begun with a whispered free association after lovemaking, progressed to careful planning interspersed with frantic, driven sex, and now she was walking into something she had fantasized about since puberty.

Randy was aware of others' eyes on her. She knew that she was beautiful, with a long mane of blond hair and a well-proportioned body. However, today, she imagined that they could see into her mind and knew where she was going. She flushed a bit and pointedly looked away when her eyes

Sharing fantasies with a lover has a powerful aphrodisiac effect, but they sometimes can lend themselves to much, much more.

encountered those of a young man sitting on one of the benches that lined the walk.

Finally, she turned off the paved path to one worn in the dirt by countless feet. It led down into a ravine that eventually reached the city landfill. She was familiar with the narrow dirt track that ran along the bottom of the ravine; it was where the more daring girls and boys came to "park" on the cool summer's nights. In fact, along this same track, she had lost her virginity in a green 1975 Ford. As she thought of it, she laughed. She remembered the car better than the boy.

Because some homeless people had set up camps just outside the fence that marked the border of the landfill, people avoided the area. "You never knew what could happen to a woman who went down there alone," they would say, giving a titter that was half fear and half fascination. Randy would join in, but her laugh had something else in it.

Now, she was alone, and the heavy brush pressed in on both sides of the narrow trail. She knew that the dirt road was just ahead...

She had no warning. Something white went over her head, blocking her view. When she raised her hands to fight, they were trapped and quickly tied together in front of her. Before she could scream, a harsh voice said, "Scream, bitch, and I'll kill you right here and now." Was it really Oliver's voice? It sounded so... powerful.

She felt herself being picked up and carried like a bag of potatoes. Less than a minute later, she was dumped on the ground. The cloth (she realized now that it was a pillowcase) was pulled off, and she looked up eagerly

Kidnap scenes should be done where no one who isn't aware of what is going on will become aware of them. This, like any kind of public scene, has a serious ethical facet. Observers, almost by definition, have not given their consent to being included. However, an even more important consideration is that the uninformed bystander may choose to intervene, perhaps with a gun. Bullets don't honor safe words.

expecting to see Oliver's face. For a horrifying moment, she stared into the face of a complete stranger. She couldn't move; she couldn't think; she couldn't breathe, and then, as he moved, she realized it was a rubber mask. Obviously, Oliver had tricks he hadn't told her about.

Pulling open her mouth, he put a rolled-up towel across it, tying the towel ends behind her head. Experimentally, Randy tried to speak, discovering that, while the towel did muffle her words, she could make sounds around it. However, before she could try again, Oliver took her chin in one hand and slapped her cheek with the other. "I said, 'No talking, bitch.' There's only one thing you'll be using that mouth for and that's sucking my cock."

His voice changed and it was Oliver talking to her. "Do your safe signal, right now." Randy complied, giving a series of three hoots past the gag followed by another three. "Good," he said. His voice changed back, "Keep that fucking mouth shut until I tell you, slut." He rolled her over on her stomach and ran a length of rope around her waist. Turning her on her back, he ran the rope from the small of her back through her legs and tied it to the rope holding her wrists together.

She flushed as the rope pulled up her skirt to the point where he could see that she had come out without panties. Embarrassed and excited, she tried to cover herself with her hands, but he pushed them to one side and ran an experimental finger over one of her pussy lips; Randy shuddered. He spread the lips apart between his thumb and forefinger. Caressing her clit with the other hand, he

Not only is slapping a turnoff for many people, there is a factor of risk inherent in hitting the head. A note on page 123 explains how to do this safely.

Harsh "gutter" language can be immensely exciting to some people. It is a turn off to others. This is a factor that should be part of a pre-scene negotiation.

remarked casually, "You really are a hot bitch. You're going to be fun to play with," as she writhed on the ground.

Still holding the pussy lips apart, he repositioned the rope so it ran directly through and pressed on her clit. Finally, he tightened the rope so her bound wrists were pressed against her mound and her fingers moved frantically against her inner thighs.

He stood back for a moment watching her struggle, then bent down and ripped her peasant blouse down from her naked breasts. The nipples were already enlarged and begging for a touch. Randy watched, wide-eyed, as he bent down and carefully and precisely bit each. Her scream seemed unnaturally loud to her ears, but the towel muffled it to the point that it could never have carried more than a hundred or so feet.

Standing back up, he walked a few feet to where their station wagon was parked and opened the rear hatch. Randy expected him to make her stand and walk to the car, but instead, he picked her up from the ground and carried her. The movements caused the rope to move harshly, and she went into such a frenzy that he almost dropped her, but he hung on until she was over the tailgate and dropped her onto it with a resounding "thump."

Oliver pushed her into the back of the station wagon and covered her with a sheet. Randy heard the gate slam and the door open and close. As the car started, she discovered that the slightest movement caused the rope between her legs to rub on a most sensitive area. Her unbound breasts seemed to be singularly sensitive too. The light sheet covering her rubbed them in a most delectable manner.

The proper way to "drop" someone like this is to simply lower them quickly so that the ass and thighs strike first. Keep a firm grip on the head and make sure that it does not strike anything. The average person cannot tell the difference between a true drop and this kind of controlled lowering, which is considerably safer.

The road was potholed and in poor repair so the car jolted quite a bit as Oliver drove toward the main road. In the back, Randy found herself first tantalized by the movements of the rope and the sheet, and then delighted with them. Soon, she discovered that she could twist her hands enough to touch the now slick flesh between her legs. The first orgasm quickly followed. She tried to stop after that, but the awareness of captivity and the constant stimulation of the rope and sheet made her even more excited.

In all, the drive to their home took four or perhaps five orgasms. She was so distracted by the third that she lost count. Oliver closed the door to the garage before opening the back hatch and pulling Randy to her feet and removing her gag. To their mutual surprise, her knees gave way and she crumpled to the floor when he let go of her. Post-orgasm giddiness made her forget the mock seriousness of her situation. "I'm a bit fucked out," she said and giggled. When he picked her up and dropped her over his shoulder again, the rope twitched, and she came yet again with a shuddering scream.

He carried her down a flight of stairs and dropped her into a chair. The furniture in their little television room had been moved back against the wall and a single strand of rope hung down from a hook in the ceiling, a hook that Randy knew hadn't been there before. Picking up a knife from a table, Oliver cut the rope that ran from her wrists to the small of her back. He pulled her roughly to her feet and attached her bound wrists to the vertical rope.

Using a knife in this circumstance can be risky. When knives are part of a scene, for example, to threaten someone, the best thing to do is to get a child's toy knife. For cutting clothing or rope, special EMT scissors (one blade is blunt to prevent accidental injury) are preferred. If a knife must be used, get one without a sharp point.

A simple whip can be made by buying a two-foot length of heavy nylon rope, wrapping the last six inches with tape and carefully unwrapping the strands to make the whip's tails. Do not melt the ends of the strands to prevent further unraveling. Nylon melts to a hard mass that can injure if it is at the end of a whip strand.

The breasts (if the woman has no history of cystic breasts and no breast implants) are acceptable targets for a whip, and most scene people agree that moderate, occasional whipping does them no harm. However, some experts believe that heavy or repeated whippings may have negative side effects.

He stepped back and looked at her. The mask gave everything a sense of unreality. She stared into his eyes and tried to see her lover there, but it was all confusing; the fantasy was taking on a life of its own. Her passion-tinged confusion was multiplied when he took a quick step forward, seized the neckline of the blouse and ripped it off her body. The violence of the act and her sudden nakedness forced a tiny scream from her as her sensual hunger reached a new level. Before she recovered, he cut the waistband of her dress and ripped it too off of her.

Randy's eyes were heavy-lidded as she watched Oliver strip off his own clothing, but she snapped back to alertness when she saw him take a multi-stranded whip from a drawer. He moved until he was standing directly in front of her and ran his fingers through the whip's strands. After a moment of consideration, he said, "I want you to suck my cock."

She recognized that this was a part of a scenario that they had discussed and so shook her head violently. Oliver reached around her and untied the now sodden towel that had kept her silent.

"It's 'No,' is it?" he said, a dangerous tone in his voice.

"I won't suck your dirty cock," Randy replied, despite an almost overwhelming desire to do just that.

"I think I'll just have to change your mind," he said and brought the whip across her chest.

She gasped in surprise. When he had casually said, "I'll just whip you into submission," she had assumed that he meant that he would whip her back or her ass. She had never considered that he might want to whip her breasts. Yet, along with the sting, there was a certain excitement. A

second and a third blow increased the sting, but they also intensified the excitement.

The stimulation made Randy thrash about and throw her head back and forth. She caught sight of something that she hadn't noticed before: Oliver had brought down the cheval mirror from their bedroom and carefully positioned it so that it reflected a view of her entire body in its angled glass. She was transfixed. Who was this beautiful exciting woman, breasts high and hair disarrayed? As she stared, the whip hit her breasts again and she watched as the woman in the glass leaned into the blow, absorbing and transmuting its power.

Her orgasm shook her, and she screamed and screamed. For the second time, her knees failed her and she crumpled until the rope arrested her fall. Oliver quickly dropped the whip and moved to support her in time to hear her say, "My master, I will suck your cock. Please let me suck your cock."

Cutting the rope and allowing her to fall forward into a kneeling position, he untied her and moved a chair so he could sit with her kneeling between his legs. His excitement was such that the act took less than a minute before he gave a cry and fell back against the chair.

Randy felt Oliver's power transferring to her. She rose, a bit unsteadily, a thin trail of cum running down one side of her jaw. "Darling, turnabout is fair play," she said with an evil smile.

Oliver, not yet recovered from his orgasm, looked at her with surprise. He didn't have time to react before she took the rope from the floor, wrapped it around his wrists

Not everyone can afford a cheval mirror, a free-standing, full-length mirror that tilts on its base, but discount stores have inexpensive sheet mirrors that can be propped against a wall to give someone a similar view.

Fellatio is rated as a moderate-risk activity in regard to HIV infections. However, Oliver and Randy are a monogamous married couple. Individuals in less structured relationships would be well advised to use a condom during this activity. Flavored ones are available at specialty stores.

and pulled him to his feet. Standing on tiptoe, she managed to fasten his tied wrists to the overhead rope. He had cut it close to her wrists and his extra height gave her enough to make a secure knot.

"Now it's my turn," she said, pulling off his mask. Now, he was Oliver again, and not some stranger. Picking up the rope whip, she ran the soft strands over his slack cock. She giggled when she noticed it twitch slightly at the touch.

"We didn't plan it this way," Oliver protested.

"We don't have to plan everything together," Randy said, standing behind him and running her fingernails lightly over his back. "What is your safeword?" she asked in a commanding tone.

"Red light," he replied softly and she could see a blush forming on his neck.

Her first whip strokes were light, almost caresses. She struck harder and harder. He remained stoic for a while, then began greeting each stroke with a low "uh." Randy paused for a second and felt his cock. It was definitely getting harder. She worked the whip down his upper back and switched to his ass. Soon the skin was covered with light blotches of red.

Dropping the whip, she said lightly, "Be right back," and ran up the stairs. When she came back down a few seconds later, she was holding a plastic bag full of clothespins, a ball of string and a wooden pizza shovel.

Positioning herself behind her husband, she swung the shovel lightly to gauge the distance, then let him have it. Five strokes later, she heard him say, "Yellow, please, yellow."

A "slow" signal is a good idea when trying new things. Similar to the safe signal, it warns the dominant that things are not yet too intense, but are getting there. It requests but *does not* mandate a slowdown.

Randy dropped the shovel and lightly massaged her husband's ass, which was now a bright and angry red. However, reaching around, she discovered something that had been flaccid a moment before was now rock hard and ready. Retaining her grip on the cock, she came around in front of Oliver and looked deep into his eyes. She could feel the passion. With her other hand, she traced a path up his leg, over his belly and chest, and circled around behind his neck pulling his head down so she could kiss him. As they kissed, she slowly pumped his cock in time with the movement of their tongues.

Stepping back, flushed and breathing heavily, she stumbled, catching herself on the edge of the couch. In a hoarse voice, she said, "I think it is time for me to have some fun." Picking up the knife, she stood on tiptoe and cut the rope well above Oliver's wrists. She pointed to the floor and said, "Lie down." As he moved to comply, she directed him until he was lying with his wrists over his head and next to one of the legs of the sofa. With the extra rope she had left attached, Randy tied them to the leg.

Picking up the rope whip, she kneeled over his face, lowering her pussy onto his mouth, and reached out to caress his balls. The first touch of his tongue sent such a spasm through her body that she dropped the whip and almost lost her balance. However, soon she steadied herself and, picking up the whip, began gently to whip her "slave's" cock. Soon he picked up the rhythm and matched his tonguing to her whipping.

Suddenly, Randy threw away the whip and, in one motion, lifted herself off his lips and impaled herself on his

CBT, cock and ball torture, is a popular activity among some D&S couples. The cock itself is a rather durable organ, but care should be taken with impact against the balls. In this case, the whipping is more symbolic than practical.

erect cock. Oliver tried to begin an in and out stroke, but she spread her knees and pinned him to the floor. A low groan of frustration escaped his lips but he made no protest while she held him immobile.

Picking up the bag of clothespins, she took them out one at a time, stringing the cord through the springs. When she finally had a series of ten, interconnected, she began to move slowly up and down, riding his cock. After a few seconds, she leaned forward and clipped one of the clothespins to a flap of flesh near his left shoulder. Oliver gave a low cry and thrust upward with passion.

Perhaps a minute later, the next clip was attached a bit closer to the left nipple. Then, one next to the nipple... then, on the nipple. The last brought a stifled scream and an almost panicked movement of this hips.

By the time all ten had been attached in a ragged line across his chest, both lovers were gasping and panting. Placing both hands on his shoulders, Randy began the twisting rolling motion with her hips that she knew would bring them both to orgasm quickly. She was right. In less than a minute, she could feel the preliminary tremors that foretold immediate eruption. Straightening up, she waited for the first spasmodic thrust; as it came, she jerked on the string, simultaneously pulling all ten clothespins free. Oliver gave a scream that seemed to go on forever as his body pumped cum into Randy's tight pussy, while she fell forward on to his chest and screamed her own passion in counterpoint.

Embarrassment

Materials needed:
Handcuffs or other bondage cuffs
Light clips with bells on them

In at least one area of D&S play, men and women seem to show distinct differences; this area is humiliation. Male submissives seem to crave humiliation to a much greater degree than their female counterparts, and more than one beginning relationship has gone over rocky ground when this topic was broached. Adding to the confusion, women do seem to enjoy an activity I call "embarrassment" to distinguish it from humiliation. Embarrassment tends to result from a person being "forced" to do something that he or she would not normally do but which does not attack core values or lower self-esteem.

For example, being ordered to partially disrobe in public would be seen as embarrassing rather than humiliating while being publicly berated or insulted would be humiliating.

Bobbi knew that something was up. Simon had been smiling his quiet, I-know-something-you-don't smile ever since he had suggested that they go to the mall – and not just any mall, but a new mall that had opened outside the far boundary of the city. As the car turned onto the approach ramp, she glanced at him, hoping for a clue, but his eyes were firmly fixed on the road and his face was unreadable.

Instead of taking several open spaces near the mall entrance, he selected one near the corner of the lot. By now, Bobbi was almost beside herself with curiosity. She fidgeted as he slowly and methodically turned off the ignition, set the parking brake and set the transmission in park. She knew he was aware of her agitation and was delaying deliberately.

> Although the idea of a public scene is exciting, ethical players always remember that consent is required from *all* participants. Involving unsuspecting passers-by isn't the act of a conscientious dominant.

Finally, he turned to her and said, "Take off your panties." For a moment, she couldn't move; then, she looked around desperately. They had made love in the car before, but that had been at night, on a deserted road. This was 5 P.M. and there were people walking about. She tried to speak, but only a frightened croak emerged. She felt a blush spreading its heat over her face and neck and shook her head wildly.

He acted as if she simply had not heard him the first time and said, "Take off your panties."

She forced herself to take a breath, fighting the tightness in her chest. "No!" She wanted to yell, to put command and confidence into it, but all that came out was a squeak that was barely recognizable as a word even to her.

Simon didn't raise his voice, but the next word had the note of command that she had learned to recognize and obey. "Yes."

While her mind whirled with stratagems and arguments, she watched in fascinated horror as her hands, obeying another will, slid the nylon panties down her long legs and over the shiny leather shoes. Only when they had accomplished their task was she able to regain enough control to use them to smooth the skirt back in place.

Internally, she grimaced. The skirt which, moments before, had seemed almost unfashionably long now seemed obscenely inadequate. However, despite herself, Bobbi found her body reacting to the situation. A familiar slickness was forming between her legs, and her breasts and nipples were tingling with increased sensitivity.

She looked to Simon for his next order, but he was silent. As she sat passively, her mind was alive with what might happen, each scenario more outrageous than the next. She visualized him taking her brutally in the back seat, on the hood, her being forced to run naked across the mall parking lot, her being tied to one of the lampposts and whipped as a crowd gathered, cheering Simon on.

"You are excited; I can smell it." His words, although spoken softly, took her by surprise and made her jump.

"Are we going to fuck?" Bobbi blushed as she spoke. She hadn't meant to say anything but the waiting was driving her wild.

For a moment, he just sat there, and, then, a slow smile spread across his face. "You *are* the horny bitch, aren't you?"

> Never be in too much of a rush. One of your most effective tools is the submissive's imagination. Give him or her time to let it range across the possibilities.

Bobbi wiggled at his words, and her nipples burned against the material of her blouse.

Suddenly serious, he said, "Hands behind you. You are tied."

This was a game they often played. Bobbi had found that imagining bonds was almost as much fun as having them on. Sometimes, they would be making love and he would position her hands above her head and say, "Tied." The illusion was so strong that, at those times, Bobbi could almost feel the rope tight against her wrists.

When she had put her hands behind her back, Simon lifted up the hem of her skirt and touched her naked pussy. Bobbi's neck arched as she moaned with pleasure. She completely forgot her embarrassment of a few minutes before and opened her legs to receive his touch. Soon, she was lost in a kind of a haze with his fingers touching and exploring. When his hand withdrew, she moaned in disappointment.

When she opened her eyes, she saw Simon smelling his finger as if it were a cork from a fine bottle of wine. He smiled at her and offered the finger to her lips. She opened her mouth slightly to allow it to enter and licked and sucked the extended finger as if it were her lover's cock.

"I guess you're ready," he said, reaching into the space between the bucket seats. When his hand reappeared, he was holding a pair of handcuffs. Before she could react, he snapped one cuff on her left wrist, turned her slightly in her seat, pulled her right wrist behind her and captured it with the other cuff.

Handcuffs are risky toys. However, the sound and feel of handcuffs are powerfully sensual. Used properly, in a psychodrama they can lend an air of excitement that more prosaic rope lacks. Because Bobbi is going to be doing a bit of moving around where there is a possibility of a fall, one of the links in the chain connecting the cuffs has been removed and replaced with thread. She feels as if she is fully restrained, but if she falls, her instinctive motions will break the thread and protect her from further injury.

Bobbie pulled tentatively against the imprisoning cuffs, but he said, sharply "Don't fight them; they could hurt you!"

His hand vanished again, to reappear with a set of red wire-clips with tiny Christmas bells attached. Bobbi's eyes widened and she made a gesture, cut short by the cuffs, to protect her nipples.

"No, darling, not there," he said, lifting and folding back her skirt. Bobbi started to bring her knees together, but he stopped her with a glance and a shake of the head. When he gently rubbed her pussy lips between his thumb and forefinger, she was caught between present pleasure and fear of what the future would bring.

He took a clip and placed it on one of the outer pussy lips. Bobbi drew in a breath as he let the clip close on the delicate flesh, exhaled with a shudder as she discovered that its touch was relatively mild.

Simon attached the second bell-clip combination to the other pussy lip. *This isn't so bad*, Bobbi thought to herself. She could feel the pinch, but it was erotic, not the agony she had expected when she realized where they would be placed.

Simon slipped a hand behind her and bent her forward from the waist until her head was almost touching the dashboard. As she remained in that position, she could hear him removing something from a paper bag in the back seat. After the rustling of the paper stopped, she felt something warm and soft being draped over her shoulders. It was a hip-length sweater jacket.

Sensual stimulation can raise the level of erotic excitement to the point that activities which could be painful to an unprepared person, become pleasurable.

Clips provide a wide range of stimulation. Because of this, test every clip on the skin between your thumb and forefinger. If it is too painful, think twice about using it on a another. Most clips should not be left on longer than 15 minutes because they may cut off circulation to the skin underneath. Clipping a small bit of skin is a much more intense stimulation than clipping a larger bit. In this case, Simon used plastic-coated wire clips (not the much more intense ones made from spring steel bent in a triangle).

Simon touched her forehead, urging her into an upright position, and opening his door, he got out of the car. In a moment of absolute panic, Bobbi realized what was going to happen and she shrank back into the seat, willing herself tiny and invisible.

Not surprisingly, she was still visible and full-sized when Simon opened her door and said quietly, "It's showtime." She shook her head mutely, but he simply stood there, waiting her out. Finally, she started to swing her legs through the opening, but stopped in horror as she heard the tiny tinkle of the bells between her legs.

"No, please, I can't go in there – not like this." Bobbi imagined herself walking through the mall under the horrified stares of the shoppers.

She looked up into his eyes, hard eyes, merciless eyes, the eyes of her master... and then looked away. He reached down and, taking the back of her neck in his hand, urged her out of the car.

Lifting her chin so she was forced to look into his eyes, Simon said, "You know your safeword; are you going to use it?"

Bobbi's first feeling was relief. She could say "red light," and it would all be over. She wouldn't have to walk into that mall with her hands cuffed behind her back and bells tinkling from her pussy. She considered the care with which Simon had set this up. The sweater covered her hands. Although the bells sounded like the tolling of Big Ben to her, she knew that the sound they made was relatively inconspicuous. He had brought her to this specific mall,

This is a delicate point in an embarassment scene. The dominant has to be able to judge if the situation is beyond the submissive's limits. In some ways, a physical scene is much easier to do. Fortunately, the existence of a safeword gives the dominant some guidance... although it does not remove the final responsibility: submissives sometimes fail to use a safeword when they should. If a safeword is not used, this does not always mean that a scene continues. The final responsibility always rests with the dominant.

far from their home and people she knew. She felt a deeper submissiveness slip over her. She dropped her eyes and slowly shook her head.

The walk across the parking lot seemed endless. Although she had worn high heels since she was 14, the modest two-inch spikes seemed like stilts today. Several times, Bobbi stumbled, but Simon supported her before she could fall. She discovered that, if she walked slowly and smoothly, the bells remained silent, although the constant pinch reminded her that they were there. The coolness of the handcuffs on her wrists was another undercurrent that was impossible to ignore. Several times, a gentle breeze ruffled the edges of her sweater, almost making her panic, as she realized that if it slipped off her shoulders the cuffs would be visible to anyone watching.

Despite herself, Bobbi found herself becoming very excited. She fantasied herself being a kidnap victim being spirited away or a slave girl being taken to the market.

Inside one of the "anchor" department stores, she found the contrast exciting. Surrounded by all of the accoutrements of the vanilla world, she could feel the constant pinch of the clips and the hard metal of the handcuffs. She gave a delicate shudder of exhilaration and froze, a blush rising on her cheeks as she heard the tiny tinkle of the bells.

Simon put his arm around her, and she took comfort in both his nearness and the fact that his arm was holding the sweater more securely to her shoulders. She felt fingers lifting the hem, and he said with a chuckle in his voice, "It's warm in here; you don't need this any more."

Automatically, she started to turn to beg, but in doing so, she almost rotated right out from under the sweater. Panic rising, she turned back into the shelter of the arm. Only when she felt his fingers back on her shoulders did she turn her head and implore him with her eyes.

"OK, darling, not right now," he said with a laugh – and, dropping his hand from her shoulder, gave her a light whack on the ass that made her jump, the bells ring and the sweater slip a quarter of an inch.

She wanted to scream, beg, run, do anything but stand there. She knew, simply knew, that every eye was on her. However, at the same time, she felt a drop of moisture break loose from her pussy and run downward along the inside of her leg.

I'm so turned on, she thought. *What is the matter with me. I hate this; one slip and everyone will see. Do I want them to see?* Unbidden, fantasies of her being naked and helpless before strangers rose in her mind. She remembered how, as a teenager, she had stood, hands above her head, holding on to the coat hook in her bedroom. Her developing nipples had been painfully erect on their then-smaller mounds. She had spread her legs wide apart as she imagined some cruel male voice saying, "Spread them, bitch. Let's see what you have."

Bobbi was jerked back to reality as Simon gave her a gentle shove. "Come on, my slut. If we stand here much longer, we will attract attention." His voice was barely audible, but Bobbi was caught off guard. As she took a quick step, the clear notes sounded again from under her skirt,

and she almost stumbled. She had to force herself to walk slowly and carefully.

Then, they were out in the mall itself. Again, it seemed that every eye was on her, but Bobbi was gettting used to that feeling. She straightened her back and sucked in the feeling of being on display. She could feel the warm slickness spreading between her legs.

When they came abreast of the Godiva shop, Simon stopped. Bobbi was so caught up in her own feelings and fantasies that she went on a few steps before she realized he was no longer next to her. Again, surprised, she moved so rapidly that the bells sounded, and she glanced around to see if anyone had noticed. However, the only one close enough to hear, the shop girl, was busy filling Simon's order for two liquid-filled chocolates.

Simon took the chocolates, paid the woman, and to Bobbi's surprise, led her away from the shop. She had been sure that he had planned to have her try to deal with the messy treat while her hands were bound. She was both relieved and disappointed that he seemed content to wait.

However, several dozen yards down the mall, he brought her to a halt and turned her so she was facing a window. In the window, placed so it would reflect the passing crowd, was a large mirror, and Bobbi found herself staring into her own eyes. Simon moved around behind her. Bobbi's eyes followed him in the mirror. For a long moment, he stood behind her, his eyes meeting hers in the glass, and reaching around her, he brought one of the chocolates to her lips.

Because a submissive can become used to anything over time, one of the primary tasks for the dominant is to find ways to alter the familiar in new and erotic ways.

Bobbi, opened her mouth, but he didn't pop it in as she had expected. Instead, he whispered, "Lick it; taste the flavor." Something in her wanted to close her eyes, but she couldn't. She watched her tongue caress the dark sweet as its flavor teased her. A spasm of pleasure shook her – and some tiny bells rang.

She pressed herself back against him, not caring any more who saw, and reached with her bound hands to caress his full erection through the fabric of her sweater and his pants.

She could see his eyes widen in surprise and glaze a bit in pleasure as she covertly stroked him. He whispered, his mouth so close to her ear that she could feel the gentle breaths, "You are such a slut. That deserves a reward." And he popped the treat into her mouth.

After being sensitized by licking the chocolate, she was overcome by the flood of sensation as she bit down and her mouth filled with the rich flavor. Again, there was the sound of tiny bells.

Bobbi turned in Simon's arms and, knowing what effect it would have on him, allowed a tiny bit of the liquid filling to drip from the side of her mouth and run down her chin. As she watched his eyes following the drop, she knew that she had had the desired effect.

"Oh, my god," he said huskily and, not even bothering to wipe the chocolate trail away, took her by the elbow and led her back along the mall. The tinkling was louder now, but neither of them paid it any heed, nor did they heed the occasional curious looks from the other shoppers.

Bobbi had expected him to bring her back to the car, but instead, he urged her through an access door and down a long, undecorated hallway. A door at the end of the hallway let them out of the mall and into an enclosed area holding some empty boxes and a massive trash compressor. It was deserted.

"On your knees," he said, the need evident in his voice. Bobbi started to comply and, then, asked shyly, "Please handcuff my hands in front of me, Master."

Desire made his hands clumsy, but he unlocked one wrist, brought her hands around in front of her and relocked it.

Gratefully, Bobbi sank to her knees. Rough asphalt bit into her but that only added to the eroticism of the scene. She pushed his hands away and opened his pants herself. That he was ready was obvious from the first moment that he had touched the front of his pants, and when his beautiful cock sprang free the tip was already glistening with pre-cum.

"Damn," he swore as he dropped his wallet. Before he could bend over to retrieve it, Bobbi scooped it up with her bound hands and extracted the condom. Sliding it over his cock, she ran her tongue along the length and took it into her mouth.

As she brought her lover and master to a fever pitch, her chained hands were busy elsewhere, and the tinkle of bells was clearly audible over the sound of their passion.

Even at times like these— in fact, *especially* at times like these — you should be careful to double lock handcuffs so they will not inadvertently tighten.

The Conversion

Materials needed:
Footsie Fetish Kit
or
Flavored massage oils & flavored dusting powder

The UPS man had scarcely closed the door before Curtis was tearing at the package's wrappings. The return address was bland and uninformative to a casual glance, but he knew what was inside. There it was – a brightly colored box with the words Footsie Fetish across the top. Curtis opened it up and lovingly ran his hands over the contents, then carefully closed it and put it aside.

Isobel came home precisely at 6:00, and they went out to the neighborhood Chinese restaurant. About halfway through the meal, she cocked an eyebrow and said, "You've got something up your sleeve. What have you got planned?"

Curtis tried to keep a poker face – something he discovered wasn't easy when choking on a mouthful of dumpling. Swallowing, he tried to meet her eyes and said. "What makes you think I have anything planned?"

She raised her hand and extended her well-manicured index finger. "One, I know that little half grin. You've got a secret you are dying to tell me." Middle finger. "Two, you have been eating like you can't wait to finish the meal. That isn't like you." Ring finger. "Three, you think I didn't notice your lighting the incense before we left. I did." Little finger. "Four, experienced observation. After all, I'm older than you are."

The younger man blushed. She could always do this to him. All his life, he had been attracted to women older and stronger than he was. With Isobel, the attraction had been impossible to resist. They had married only weeks after meeting. He thought, everything would have been perfect... except.

She had been so strong, so dominant. He had been sure that she would have leaped at the chance to play the kinds of games his other lovers had relished. Instead, Curtis had discovered that she really believed in the feminist ideals of equality and shared power, instead of translating them, as so many women, into a belief in female superiority.

His hinting had struck a stone wall of idealism. Fortunately, he had desisted before causing a rift in their relationship, but the longing remained, burning low, hidden, but far from extinguished. Hope had resurfaced in the form of a discreetly phrased advertisement. Now, he had a plan.

Curtis hung his head... largely to hide a smile of anticipation. "There is... a surprise waiting for you back at the apartment. It is the half-year anniversary of our meeting, and I got... well, it's sort of a half-joke, half-sensual experiment."

People are often more ready to experiment with power exchange if it is presented in a light-hearted or humorous context.

That got her attention. Isobel was as sensual as a cat. It was one of the things that attracted him to her. She had brought a collection of sex toys to their marriage bed that would have been the envy of many a Times Square erotica dealer. He knew that she would love what he was planning. He had always known that, but had just lacked the key.

She asked what the surprise was, but Curtis stood mute. Shaking his head and holding his finger across his lips, he said, "You have to see it... and feel it." That did the trick. They both finished the meal in record time. On the way back to the apartment, they walked with their arms around each other and stopped several times to exchange caresses – to the amusement of passersby, Curtis was sure – but he really wasn't paying attention.

As he had planned, the apartment was redolent with florals when they opened the door. Curtis settled her on the couch and got the box from the closet. Holding it behind his back, he said, "It's sort of a massage kit," and handed it to her. She turned the box over in her hands as if it were some strange and wonderful artifact, then read aloud the words under the label, *Enjoy the passionate experience of sensually playing with each other's feet.*

He took it out of her hands and said firmly, "It is a gift for you, so you get it first." In his heart, he hoped there would be no "second."

She looked reluctant for a minute and, then, gave him that feline smile he had come to know so well. "All right, if you want. It sounds like it might be fun."

Curtis was already on his way to the bathroom. Over his shoulder, he said, "Take off your shoes and stockings;

> Novices at accepting power from another are often more willing to try if they believe that turnabout will take place. They often have great difficulty in understanding "what a submissive gets out of this."

The complete accep-
tance of pleasure from
another can be, in
itself, an immensely
erotic act.

Third-party authority
can help an individual
to overcome his or her
nervousness in an
initial scene.

I'll be back in a minute." He longed to do that for her but knew that he couldn't move too fast without arousing her suspicions.

In less than a minute, he was back with a warm bowl of water, a face cloth and a fluffy towel. Before she could protest, he knelt in front of her and began to wash her left foot. As he expected, she immediately protested. "You don't need to do that." But he was ready.

"The instructions say the feet have to be clean before you do a massage," he responded, lying; there weren't any instructions, but it reassured her enough so that she relaxed a bit. Slowly, carefully, he washed her foot. *God*, Curtis thought, *how I want to kiss it and gently suck each toe, but that would be too much, too soon*. He could feel the tension going out of her arch, her ankle relaxing. He put down the left foot and took up the right.

As he worked on those he could feel her aura changing. She slumped a bit in the chair and her feet became soft and malleable. As he cleaned between her toes, she gave a soft sigh of pleasure.

"They are so tired," he said softly drying each foot. "I can feel how tired they are. What you need is a nice massage." Curtis took the bottle of eucalyptus massage cream and warmed a bit of it between his hands. He sat cross-legged in front of her and settled her left foot in his lap. He was thinking, it feels so good against my cock. He had a moment of apprehension that she might feel the straining erection through the fabric of his pants, but if she did she gave no sign.

He smoothed the warm cream over the bottom of her foot and began a circular motion with his thumbs to work it deeper into her skin. The moan this time was deeper, with more heart. The arch relaxed and welcomed his thumbs like a pussy accepting a lover's cock. She was no longer holding the foot up. The muscles in her leg had relaxed, and he had complete control of the lovely extremity.

Adding a bit more cream, he worked each toe separately, massaging them between his thumb and forefinger and gently pulling them to relax the tiny muscles.

"Ah, ah, ah," she gave soft exclamations of pleasure as he tugged each toe. He risked a look up and saw that her eyes were closed and her head was thrown against the back of the chair. As he watched, her little, catlike tongue made a quick circuit of her lips, caressing them and making them glisten.

Curtis risked a quick kiss of her big toe and was rewarded by a gentle murmur of pleasure. He put the left foot aside and picked up the right. Again, he warmed the lotion. By now, the odor of eucalyptus was mixing with the floral incense. This time she was ready. Her foot was relaxed. It welcomed his caresses, and he could feel her breathing accelerate as he traced out the arch with his thumbs. His erection was almost painful as he searched out the tension knots and erased them with his loving touch.

Perhaps without her conscious volition, her hands drifted to the front of her stern, businesslike blouse and began to stroke her full breasts through the fabric.

When Curtis singled out the individual toes, she gave a loud gasp, and her fingers dug deeply into her breasts.

Watch the individual with whom you are playing. Often their unconscious movements tell volumes about the success or failure of a scene.

Her gasping became faster and sharper as he moved from left to right fingering each toe until he bestowed a more courageous kiss on the big toe. When she felt his lips close over it, she went rigid for a moment, cried, "My *god!*" and fell back against the chair's cushions.

He put the foot down and moved behind the chair. She tried to look around and started to say, "Thank you, Curtis. That was..." but he silenced her with a touch of his fingers on her lips. Bending, low next to her ear, Curtis whispered, "It isn't over, darling," and lightly massaged her forehead with his oiled fingers. She sighed and snuggled deeper into the cushions as he let his fingers drift between her blouse and her skin. Lightly kissing her forehead, he slid his hand under her bra to lightly squeeze each nipple. A low moan escaped from her lips and her eyelashes fluttered a bit.

Lightly massaging one nipple, he removed the other hand and undid the buttons of her blouse and with a deft twist undid the front fastening of her bra, freeing her breasts.

Getting a bit more cream, he lightly coated her breasts with delicate finger strokes until she suddenly reached up and grabbed both of his wrists. There was a moment of panic when he thought that she meant to stop him, but she only wanted to guide his hands to giving her greater pleasure. This time her cry of pleasure was louder and a new odor, the scent of aroused woman, competed with the eucalyptus and florals.

As she rested, he washed his fingers in the bowl of warm water and took out the bottle of cherry-flavored

"tootsie drops." Putting a few drops on one finger, he offered it to her lips. "Taste this, darling," he said.

Willingly, she opened her mouth and accepted the finger, sucking it as though it was a cock. "Hmm," she said, "that's delicious; you're delicious."

"It's one of the flavors from the kit," he said.

"What are you supposed to do with it," she said in a dreamy, relaxed voice.

> Allowing a novice to sample what you are experiencing can lead to much greater acceptance of the acts within the scene.

"This," he said, putting a few drops on the tip of her big toe and smoothing it in. Wordlessly, she moaned with pleasure. He steeled himself and took her toe into his mouth. Curtis felt like he was going to explode. All the times he had helplessly watched her trim or paint her nails had been twisting the spring tighter. Now, he was there. He felt the contours of her toe with his tongue. The flavor of the cherry was tinged with *her*. His universe contracted to the two of them.

Her gasp brought him back to reality. *Have I offended her*? was his first thought; *is she about to reject this greatest of all presents?* Without stopping what he was doing he looked toward her face. Something inside of him smiled. Her face was flushed as she threw her head back and forth on the cushioned back of the chair. Far from reaching down to push him away, her hands were fastened, talon like, on her breasts as she played with the nipples.

"Oh, God. Shit, that is soooooooo good," she babbled, pushing her foot closer to him. He ran a cherry-flavored finger between her toes and followed it with his tongue. Her words deteriorated into a half scream. He held her foot in one hand while, with the other, he unfastened his pants

and freed the "little captain" that had been crushing himself against the fabric in his excitement.

Curtis knew that a touch of his hand would be all that was needed to push him over the edge, but he abstained; he wanted to draw out the pleasure of his victory over Isobel's inhibitions.

He drew a line of piña colada flavor along her instep, across her arch and onto her heel. When he licked it clean, Isobel screamed, struggled and fell limp.

Again, he offered her the flavored finger, this time with the piña colada flavoring, and she drew it in with the avariciousness of a newborn at the nipple.

When she had licked it clean, her heavy-lidded eyes opened and she said, shyly, "Aren't you going to do the other foot?"

Curtis could no longer hide his smile of triumph as he picked up the other foot, flavored the big toe and slid it into his mouth. Soon, they were moving in unison, her writhing echoing the tantalizing strokes of his tongue and the movements of his lips. He explored those feet that he had so long watched from afar with sight, touch and taste.

Glancing upward, he saw her cradle her right breast in her hand and lift it so that she could lick and suck the nipple that seemed to have grown to the size of a strawberry. Pausing from his pleasurable task, he dipped the kit's applicator brush into the bottle of wild-berry-favored dusting powder, stroked it on her left nipple and offered it to her eager mouth.

With her eyes locked on his, she accepted the offering and moaned with pleasure around it. Releasing the nipple,

she pulled his mouth to hers. The kiss was more ardent than any he could remember and he felt the fire in his groin rise to a new intensity. When her hand found his rampant cock, it was all he could do to keep from exploding.

She thrust him away, and a new intensity was in her eyes. "Put lots of oil on my feet," she commanded in a husky, passion-laden voice.

Curtis fell back to his knees and quickly spread a new layer of the eucalyptus cream on her feet, but before he could smooth it in, she pushed him back into a position where he was half reclining supported by his hands behind him, looking into eyes which blazed with something he had never seen before.

She, too, leaned back, and reaching out for him with the newly slick feet, she took his cock firmly between them and began a rough, back and forth motion. The strength in his arms disappeared, and he fell the rest of the way back to the floor, but Isobel didn't miss a beat. The feet, her feet, inflamed him until he lost all control and came in an explosion that seemed to go on forever. Somewhere, he could hear someone screaming in passion and was vaguely surprised to recognize his own voice.

After that, the pictures in Curtis' memory were disjointed: his licking her feet clean, two exhausted people staggering to the bedroom, falling asleep, still mostly clothed, arms entwined.

Now his life is wonderful. They watch television with him sitting at her feet gently massaging them through the evening. In bed, she offers him those delightful extremities for their mutual pleasure.

The Transformation

Materials needed:
Magic Shaving Paste
Straight razor (or safety razor)
Cosmetics
Wig
Plastic pussy
French Maid outfit
Stormy Leather "Nubby Stretcher"

When Curt came home from work and saw Linda wearing her black leather skirt and leather gauntlets with a riding crop in her left riding boot, he thought he knew what the evening had in store. He was to find out quickly that he was wrong.

Before he could speak, she grabbed his tie and said firmly, "I want a maid."

His first reaction was confusion. Linda had never mixed household disputes with their scenes. Indeed, this was almost an article of faith between them. During the scenes, she was in absolute charge, but during other times, they made household decisions as equals.

While many people find fetish gear exciting, it isn't vital to a scene, and often a single piece will evoke as much excitement as an entire outfit.

Then, he realized the actual import of her words, and his knees became weak.

"Strip," she said.

Anxious to comply, he started past her to the bedroom, but she stopped him with a light whack of the riding crop across his chest. "Here! Now! Strip!"

The trappings of power in the corporate world soon formed a series of irregular mounds around him as he stood naked, ready for her next command.

"Kneel!"

Curt sank to his knees and lowered his head submissively. He felt his wife move around behind him and heard a light clink of metal on metal, and a collar passed in front of him, and he felt it being buckled behind his neck.

Linda fastened a leash to the ring on the collar and, with a tug, indicated that he was to follow her. However, when he started to rise to his feet, she whacked a nearby table with the crop and barked, "On your hands and knees! How dare you rise without my permission?"

Moving just fast enough so that Curt had to scamper to keep up, Linda led him into the bedroom where a sheet-covered chair sat in front of her makeup table. She sat in the chair and lifted his chin with two fingers until he was looking into her eyes. Bending close, her eyes twinkling with glee, she said, "Right now, you are a pet, an animal; would you like to be a human being again?"

Curt tried to lower his head, but her fingers felt like twin bars of steel. He could see expectation in her eyes. "Yes, My Lady," he said softly, and she allowed him to drop his head.

For many people, the collar is an important part of the submission scene. It evokes feelings of being controlled and owned. However, in many cases, the collar need not be fancy or expensive. A simple chain and lock or a pet collar purchased at a local store may "do the job" as well as something more complex and costly.

Setting up situations where the submissive will fail is a common fixture of the scene. However, with most people, care should be taken so that the failure isn't taken as a true indication of incompetence or inadequacy as this may strike at the submissive's core values and do real psychological damage.

"Very well, you will become a human again, but it will be as a woman. I believe that deep down in your heart you really are a woman... so I'll call you Verity because this is your true nature."

Curt's eyes widened, and the muscles in his back stood out, but he remained silent.

"Now, Verity, sit in this chair," Linda said, rising.

When he was seated, Linda moved around him like a sculptor deciding where to first strike. Finally, she lifted and tilted his head. "Well, my Verity would never have a five o'clock shadow. We'll have to remove it."

"Yes, My Lady," Curt said, attempting to rise, but Linda put the tip of her riding crop against his chest and pushed him back into the chair.

"I said 'we,' you daydreaming slut," Linda said forcefully, and she took a straight razor, a can of shaving cream and a towel from a box next to the desk. Removing the collar, she spread the cream over Curt's face and neck, first with her palm, then with the tips of her fingers. He sighed and closed his eyes, his body sagging a bit as he savored the satiny touch, but his eyes opened wide when he heard the sound of her stropping the blade on one of her riding boots.

With two fingers of her left hand, Linda tilted back his head and, with her right, guided the keen steel across his cheek. Tendons and veins stood out in his neck as he fought to keep his head still.

But, as she continued removing the soft foam, he relaxed. By the time she removed the last of the whiskers from the hollow of his throat, his eyes were half closed and

"Pet" or fetish names are a common part of scene play. Many men enjoy the terms "Master" or "Sir." "Mistress" is a common name for a female dominant, but some dislike it because of its subordinate connotations (a "kept woman") and choose other terms.

Obviously, this scene could be done with a simple safety razor or even a good quality electric razor, but a straight razor has a psychological impact that is orders of magnitude greater. Straight razors are not all that difficult to learn to use. A basic rule of thumb is to practice first by removing shaving cream from a balloon and, later, on your own body.

his erection was firm. As she reattached the collar, his cock moved slightly and grew noticeably.

Wiping away the last of the shaving cream, Linda stood back and said, "Well, the hairless chest works, but I guess I have my work cut out with those legs." From the box, she took out a pair of latex gloves, put them on and squeezed some white paste from a large plastic tube onto Curt's legs. With commanding strokes, she spread the paste over the skin.

With a finger, she flicked his balls. "Hmm, those are hairy, but I've got other plans for them."

Linda removed her gloves and dropped them into the trash basket. She cocked her head saying, "So far so good, but your eyebrows look like demented caterpillars. We'll have to deal with them next." And she took out a pair of tweezers.

Again, Curt's eyes opened wide. "Noooo," he breathed softly.

"But, yes, my little Verity, we have to make you look all lovely, and we can't do that with those," Linda made a face, "ugly things over your eyes. Women do this all the time. Don't tell me that you don't have the guts of a teenage girl."

Curt dropped his eyes, but in his hands, still gripping the arms of the chair, muscles stood out in relief and his erection wilted as if it were trying to hide from the tweezers.

When the first hair was pulled, he jumped involuntarily. He controlled himself better for the second and third. By the time Linda was finished, he was again slumping in his seat.

Linda turned her head one way and the other, evaluating her handiwork. Finally, she nodded. "That will do; that will do nicely. We can fill them in a bit with eyebrow pencil before you go to work tomorrow. It wouldn't do for a computer magnate to go to work with pretty eyebrows."

Curt didn't say anything, but his eyes sparkled with gratitude.

Next, she smoothed on a makeup base that completely concealed the beard line and lightened Curt's complexion. This was followed by a bit of rouge. Perhaps it was her touch, her presence, or the transformation that was under way, but Curt's erection returned, harder and stronger than before.

Linda stepped back and, putting her hands on her hips, said, "Yes, definitely yes, you are coming along. It will be fun to have a sluttish maid, Verity." Curt, on the other hand, was staring into the mirror, his eyes wide. This expression didn't change as Linda painted his lips, reshaping them with color until they were full and rich; she outlined them with a darker color to make them even more striking.

Glancing down, Linda noticed Curt's swollen erection. "Poor thing," she said as she patted it. "We are going to have to deal with you." Curt looked at her in shock. The slow smile she gave in response did nothing to ease his evident apprehension.

Getting up, she went into the bathroom and emerged with a pan of water and a towel and facecloth. Wetting the facecloth, she rinsed the drying white paste from Carl's legs. Most of the hair came off with the paste, and the rest broke

> While humiliation may be part of a scene, we as dominants should think carefully so that we don't inadvertently expose our submissive to ridicule outside of the confines of the scene itself. Bruises and whip marks are obvious examples.

"Magic Shave" is a powerful depilatory sold largely in Afro-American neighborhoods. It is seen by many as both cheaper and more effective than the products sold for women. The latex gloves are needed because the tissue in finger- and toenails is very similar to that of hair. Although Magic Shave should be kept away from mucous membranes, the pubic area can be depilated by using a condom to protect the cock itself.

off under a vigorous toweling. Linda ran her hand over the baby-smooth skin. "Lovely, you'll look so good in nylons."

Curt's eyes were next. Linda applied eyeliner and eyeshadow until they were large and striking. Finally, she glued a set of long, delicate eyelashes into place. The eyes that looked into the mirror were wide with surprise... and something else. As Linda watched Curt looking at himself, she could see a kind of hunger, one that he hadn't known about himself, and one that was growing sharper by the minute.

From a box by the dressing table, Linda extracted a black pageboy wig. Slid into Curt's hair, it framed the redone face to perfection. For the first time since Linda had begun to work on him, Verity spoke a coherent sentence. Never taking his eyes off the face in the mirror, he said, his voice trembling with emotion, "I'm beautiful; I'm a beautiful girl." Dropping from the chair to kneel before Linda, he continued, "I'm your beautiful slave girl."

"Not quite yet," Linda replied. "We have a girl's head, and that can be... useful, but I want a whole girl." She pushed him back against the chair and gestured for him to sit in it. She went over to the closet and took out a suitcase.

"Girls don't have fat, ugly cocks," she said extracting a cheap-looking cardboard box from the suitcase. Through a cellophane window in the box, Verity could see flesh-colored plastic and a kind of brown fur. When Linda removed it, Verity's painted lips opened in a silent "Oh!" It was a replica of a woman's genitals, complete with hair.

She sat motionlessly as Linda held it against his cock, turning it one way and another.

When Linda spoke, her bantering tone belied her words. "Well, I must have made a mistake. There just isn't any way to put that thing on with the fat cock behind it. I guess I'll just have to take it back." She reached into the bag, but her sparkling, dancing eyes never left Verity's face, whose eyes flicked between Linda's eyes and her now invisible hand. When the hand reappeared, the motion stopped; Verity's eyes were fastened securely on the object it held. About four inches long and one and a half in diameter, it was a tube of leather, lined with sharp-looking metal nubs.

"Can you guess what this is for, dearest?" Linda asked. Looking down at Verity's rapidly shrinking cock, she said, "Yes, I guess you can. Opening the snaps on one side of the leather device, she put it around his slack cock and snapped it closed. "Those aren't as sharp as they look," Linda said chattily," but they will 'remind' you that nice girls don't get erections." Flicking it with a finger, she added, "The people who make it call it a 'Nubby Stretcher'; I can see the nubby part, but you sure as hell aren't going to do any stretching in there. Stand up!"

Because the last words were spoken in a tone of command, Verity found herself standing almost before her mind, whirling and trying to digest all the new feelings and thoughts, was consciously aware of what Linda had said. She flinched as the sudden movement brought a few of the blunt spikes inside the stretcher in contact with her most delicate flesh.

Real French Maid outfits can be very expensive, although they are popular items at shops catering to transvestites. However, inexpensively made outfits can be purchased just prior to Halloween at discount stores. It does seem that these stores stock more of this particular costume than would be justified by the vanilla demand. Could they know something that they aren't telling?

Linda used a series of straps around Verity's legs and waist to attach the artificial pussy. Verity noticed but decided, wisely, not to comment that the stretcher made more of a bulge in the device than her erect cock had made.

Next, Linda had her don a pair of pantyhose, followed by a padded bra. Finally, she handed her a French Maid's outfit. By this time, Verity was lost in a world of her own. With clumsy fingers, she put on the skimpy dress and struggled into the high-heeled shoes.

Finally, she stood upright, unmoving and eyes unfocused. Not ungently, Linda grasped her by the shoulder and turned her until Verity was looking into the mirror on the dressing table. A shudder passed through her frame as the newly created woman goggled at her reflection. Her hands trembled as she ran the tips of her fingers over her body. Dropping her eyes, she said in a voice high and sweet, "What may I do for you, My Lady?"

Humiliation

Humiliation is a very sensitive subject for many people. While harsh, insulting words can do more damage than a poorly delivered caning, some find humiliation to be very arousing. Because of the wide range in responses to this activity, it is important that the couple discuss their relative turn-ons and turn-offs in depth before trying such scenes. Also, more than in most other activities, there is a danger that the dominant will encounter difficulties with emotional landmines in providing humiliation.

Finally, because the level of physical discomfort tends to rise arithmetically while the level of psychological discomfort tends to have a logarithmic curve, submissives should be encouraged to call their safewords in humiliation scenes before the turmoil becomes unbearable. Waiting until the last second may mean that, before the word is uttered and understood, lasting psychological harm has taken place.

Materials required:
Short chain and lock
Dog leash

Dog dish

Rattan or bamboo cane

Because of the intensity of humiliation scenes, it is a very good idea to have some overt symbol to mark the beginning and the end of the scene. This helps prevent psychological "slop-over" that could adversely affect a couple's vanilla lives.

The proper way to deliver a "safer slap" is given on page 123.

"Trampling" can be a risky activity but has a tremendous psychological impact. After all, such phrases as "dirt beneath her feet" and "less than the dirt she walks on" are a part of our language for very good reason. See the appendix (page 121) for a more complete discussion.

Bob was just putting the finishing touches on a brief he was planning to present in court on Friday when Ann came into the room. She had a length of chain in one hand, a lock in the other and a glitter in her eye.

"Worm," she said, tapping one high-heeled shoe on the floor. Dropping the chain on the desk, she looked him directly in the eye and said, "Put it on!"

Bob knew he could refuse, and nothing would happen, but the hard, cold chain drew his eye. He felt his erection growing and, with a shaking hand picked up the chain, looped it around his neck and clicked the lock in place.

"You useless pig, get out of that chair and on the floor where you belong." Bob dropped to the floor and, craning his neck to look at his lovely wife towering over him, waited for the next command.

Instead of speaking, Ann reached down and grabbed his chin in her left hand, stretching his neck even further. With a full-arm swing, she brought her other hand around to slap him vigorously on the cheek.

"Stop looking at me!" she screamed. "You haven't earned the right to look at me. Look at my shoes. Think about how far below me you are. In fact, I'll show you how far you are down there. Lie on your stomach."

Without protest, Bob lay face down, full length on the carpet. Steadying herself with one hand on the desk, Ann put one foot on Bob's ass and stepped up on him so that her full weight was resting on his buttocks.

Bob felt himself being pressed into the carpet, becoming less and less as his wife carefully placed her foot in one place and, then, another. Occasionally, he would feel a sharp pain, in contrast with the intense, but diffuse, pressure, as she lowered a heel and pressed it hard against a muscle. He knew that even through his clothing he would have marks for the next few days... and gloried in the thought.

Stepping off Bob, Ann said, "On your back, *now!*"

After Bob had rolled over, Ann again mounted him, placing both feet on his chest. She lifted one foot, presenting it to his mouth, and snarled, "Lick it." An almost tangible wave of submission came over Bob as he extended his tongue and tasted the bottom of his wife's shoe.

"Don't just touch it; lick the goddamn thing, you sniveling wreck. If you don't do a decent job, I'll make you do it all over again at noon in the middle of the mall."

Bob's eyes glazed for a moment, as he imagined himself kneeling amid a crowd of mocking onlookers. He groaned, and Ann, recognizing that she had hit the right note, expanded on the theme.

"I'll make you kneel there in only your underwear and kiss and lick my shoes while everyone laughs and points at you." She tilted down her shoe, so he could take the tip into his mouth and suck it. "Then, I'll have all those teenage bimbos sit next to me and you'll have to clean all their shoes while they giggle and talk.

"I can just hear it. 'Gross, look at the old man's hairy back' and 'Look at the bald spot; I can see myself in it.'"

Some submissives treasure marks and bruises as tangible memories of the scene that caused them. This is not true of all and this is a proper item for discussion.

Since the bottom of a shoe can pick up some distasteful material, some dominants carefully clean their shoes before a humiliation session. Others have specific shoes that are only used for these sessions. One professional dominant requires her clients to buy her a pair of shoes. These are kept in a closet and used only for scenes with that client.

Bob was extremely sensitive about his hair loss, so the comment struck much sharper than it had been intended to. When he called his "slow word," Ann did not stop the session, but she changed its direction away from an area that was too painful for him, changing it to something he could manage more easily.

Bob pulled back a bit and softly said, "Yellow."

Ann considered for a moment and stepped off him and, toeing him with her shoe, said, "Strip; dogs don't wear clothing; get naked, you shit."

He started to get to his feet to take his clothing off, but Ann pushed him back to his knees. "Only good dogs get to stand on their hind legs. Back on the floor where you belong."

She sat down in a comfortable chair while he struggled out of his clothes, while making continual comments about his incompetence in undressing. When he was finished, she whistled loudly and said, "Come here!" On his hands and knees, Bob crossed the carpet and waited, eyes downcast, for the next command. Time seemed to stretch as she remained silent. He wanted to look up at her, but he knew better.

It may have been a minute, but it felt like five, ten, an hour. Finally, Ann spoke in a soft voice. "That's better, puppy. Now, let's see if you are a good dog. Take my shoes off and worship my feet with your tongue."

She clipped a dog leash onto the chain around his neck and pulled him toward her feet. Gently and carefully, Bob removed her shoes. Her feet and legs were naked with no nylons or pantyhose to come between his questing tongue and her hot skin. Beginning with the top of the foot and the ankle, he began to lick, but before he could do more than a few strokes, Ann placed her other foot squarely on his chest and pushed him back sharply. Stunned by surprise, he failed to catch himself and fell onto his back.

"Worship! I said, Worship, you stupid cur! I don't want you slobbering all over my feet. Neatly, precisely or I'll have you practicing on the toilet bowl." Ann extended her foot again for his attentions.

This time, Bob was careful about gently kissing her feet and drying his tongue, moving over the top and sides of her feet. He ran his tongue along the bottom of her foot. He was rewarded by a low moan. Risking a glance, he saw that she had opened her blouse and was playing with her breasts.

The sight was so delightful that he neglected his duties for a moment. Ann's eyes snapped open and something like an electrical discharge passed between them as they shared the moment's energy. She recalled her role and snapped, "I warned you about looking at me. On your knees. Now, bend forward until your head is on the floor."

Bob did as he was directed. He could hear her moving, but the first warning of his imminent punishment was a swishing sound. Before he could brace himself, a line of fire cut across his ass, and he fell forward with a scream.

Bob flailed about the floor, his higher faculties overridden by a red haze of pain. He heard Ann's voice above him.

"Have we learned our lesson for today?" The voice was light and mocking. "I'm very angry with you. I was really getting into that, but you broke the rules, and I had to forgo my enjoyment to correct you. Now, I'm out of the mood. I guess I'll have a bit of lunch."

In the kitchen, Ann took a plastic pet dish from a paper bag. She casually dropped it in front of Bob who

Interspersing periods of silence and inactivity throughout a scene allows the submissive's imagination time to work and builds the tension. Each period should be long enough to give the submissive time to think but not so long as to allow the momentum to slow.

While canes can be an extremely sensual adjunct to some scenes, they require a slow buildup. Used like this, they are nothing but punishment and punishment at such an intensity that many submissives may immediately safeword.

Obviously, had Ann really been angry at Bob, she would have stopped the scene rather than inflicting punishment. Real anger has no place in D&S play because it can affect judgement and because this is *"play."* To bring serious matters into it eventually will diminish the enjoyment for all the participants.

While dog food is perfectly acceptable to eat, Ann had emptied and cleaned the can, replacing the contents with cold beef stew.

stared at it with surprise. From the refrigerator, she took an already-opened can of dog food, spooning the thick, lumpy mess into the dish while he looked on in horror.

"I said we were going to eat lunch; now, *eat!*" she said, pulling his chain for emphasis.

Bob shook his head. "I don't know if I can do this."

"Dogs don't talk back; in fact, they don't talk at all," Ann screamed at him and, putting her foot on the top of his head, firmly pushed him down into the unappetizing mass.

Shock made Bob open his mouth just in time to get a faceful of glop. His first reaction was nausea, but it was quickly overcome by a wave of submission. He swallowed, fighting his rebellious stomach. Her foot relaxed a bit, allowing him to rise enough to get a breath of air before forcing him back down into the dish.

"Eat it! Eat it, doggie. Be a good doggie."

By a supreme act of will, he took another mouthful and, then, another. Vaguely he was surprised that dog food actually tasted this good. Occasionally, when he flagged in his efforts, Ann would push his head back into the dish. By the time he was finished, his face was a mask of juice, bits of meat and other, less recognizable, fragments. He risked a glance at his mistress/lover/wife. She was standing over him shaking her head. He quickly looked away, remembering the burning stroke of the cane.

She jerked the chain. "Come on; you are filthy. We are going to have to get you cleaned up."

Eyes down, Bob followed her on all fours across the living room and bedroom, into the master bath. The tiles

were cold against his hands and knees, and the sticky mass drying on his face was a constant reminder of his status.

"Get in the tub. Lie down on your back. Close your eyes."

The porcelain of the tub seemed even colder against his back and he resisted the impulse to refuse. He was her slave and whatever she wanted he would do. Bob heard her moving about and braced himself for her to turn on the shower. He prayed that she would use the warm water and not blast him with either very cold or hot.

When the first of the stream hit his chest, he relaxed in its warmth for a moment and stiffened. There was no sound of a shower and there was a sharp tang of ammonia in the air. His eyes flew open. For a moment, the perspective was so wrong that he could make no sense out of what he was seeing; then, he realized that is wife was standing above him, naked, a stream of bright yellow urine cascaded from between her legs, striking his chest and splattering.

"I told you to close your eyes," she said sharply and moved her hips so that the yellow stream moved up his chest and deluged his face.

Sputtering, he tried unsuccessfully to keep it out of his mouth and nose. Finally, the stream slackened and stopped as she finished emptying her bladder. The residual urine on his eyes and eye lashes forced Bob to keep his eyes closed, but he felt Ann's legs on each side of his head and her warm, fragrant sex was pressing against his mouth. The sharp taste of the urine mixed with the sweet taste of her natural lubricants as he used his lips and tongue to bring her to orgasm.

Water sports or "golden showers" are quite arousing to some people. Interestingly, they are also relatively safe. Absent an infection which might allow blood products to enter the bladder, urine is almost sterile. Those who want to indulge in this activity in complete safety often do "auto showers": they collect their own urine, which their partner warms and pours on them.

She rose, and he heard the welcome sound of water first running from the tub's spout and, after it had reached the right temperature, gushing from the shower head. He lay still, luxuriating in the rosy bliss that seemed to surround him.

Again, having a specific symbolic action to end a humiliation scene often allows both parties to comfortably return to their conventional orientations without confusion.

A pair of lips found his, and he felt a tug as the chain was unlocked and slid from around his neck. "Well," Ann said," you're a human being again and my darling husband and lover." She stroked his rampant erection. "Let's go into the bedroom, and I'll see if I can do something about that."

Self-Bondage

*Self-bondage is **not** something I recommend. It is extremely dangerous even with the safeguards explained in this story. If you can't find a loving D&S partner, consider confiding in a trustworthy friend and having him or her stand by (perhaps in another room) so you can call immediately for outside assistance. However, I recognize that some people will still indulge in this activity by themselves and present this illustration on how to do it in a safer (it is **not** safe!) fashion.*

Materials needed:
3 locks (identically keyed)
Two sets of keys for all locks
Ice mold
Ink
Butt plug
Handcuffs
Two pieces of cloth, four inches by two feet
Lengths of chain
Oil of wintergreen

Freezing keys in ice is a safer way to keep them unavailable during the self-submissive's period of bondage. Tricks using candles or timers are much less prudent. Timers can become unplugged and are vulnerable to mechanical and power failures, while candles present a serious fire hazard.

The call assured that, should something happen, there would be someone aware that all was not well.

Because of the structure of the foot, it is much more difficult to wiggle out of ankle bondage than it is from wrist bondage. Therefore, there is no reason to fasten either leg cuffs or chains tightly around the ankles.

John checked the freezer, lifting out the plastic mold and shaking it to see if it had frozen through. It had. A bit of warm water over the mold and the clear cylinder of ice slid free. Clearly visible through the fracture lines and white specks was the pair of keys that John had suspended by a string within the mold the previous evening.

He held the cylinder at arm's length for a moment and brought it to his lips, savoring the clear, cold, metallic flavor of the ice. Putting it on the kitchen floor where the ice could slowly melt without damaging anything, he took down the water glass and slowly filled it halfway to the brim with ink. Carefully, so as not to cause a splash, he dropped his spare keys into the ink. Walking into the living room, he put the glass down in the middle of the oriental rug.

Then, he dialed a friend's number. No one was at home – as he had expected. Speaking carefully, he left a message. "This is John. It's about noon. I've been called out on business, but I will definitely be home by six. Could you come over then or give me a call? I've got something I need to talk to you about. It's pretty important."

The preliminaries completed. John emptied a canvas sack on the kitchen floor. A cascade of chains and miscellaneous objects emerged. He stripped naked, neatly piling his clothing on a chair. He greased and inserted a butt plug, grimacing with pain as it slid home, leaving him with the contrasting feelings of fullness and vulnerability.

He ran one length of chain between his ankles and locked a loop from each end around each ankle with a pair of padlocks.

Taking another chain, John ran it from the middle of his chest under his right armpit, up behind the shoulder, and back across the chest to his left armpit. From there, he ran the chain across his back to his right armpit. Bringing it under the arm, he ran it across his chest and over his left shoulder. Then, he brought the chain directly down the back of his shoulder and through his left armpit and locked the ends together. This left him with a single horizontal chain running across his back and an "X" of chains across his chest.

As he lay down, he flinched and gasped as his naked skin came in contact with the chill flooring. Bending his knees and bringing his heels up against his buttocks, he reached behind himself and ran a last loop of chain through the ankle chains and under the chain across his back, connecting the ends of the loop with another padlock.

He removed a bottle of Oil of Wintergreen and, with the applicator, put a bit on his balls and on his nipples. As the tingling began, he wrapped a length of soft cloth around his wrists, looped a pair of handcuffs through the chain "X" on his chest and snapped them over the padding on his wrists, making sure that the keyhole in each cuff was pointing toward his hand rather than upward along his arm. Using an unbent paperclip, he pressed the double-locking mechanism down and threw the now-useless clip into a corner.

The erotic feeling of helplessness settled over him like a comforting blanket. Fantasies flooded into his head. He was an erring slave, a prisoner of an Amazon army, a servant

> The second set of keys provides both a backup and a way to get free reasonably quickly if something untoward should happen. All Morgan has to do is knock over the glass and retrieve the keys. However, the damage to the rug from the ink makes this an action of last resort. If he becomes ill or the house catches fire, the keys will be available. Without such a motive, they might as well be on the far side of the moon.

Padlocks that use identical keys are often sold in sets. These are much safer than ordinary padlocks because, in an emergency, there is no delay in matching the correct key with the correct lock.

Handcuffs are dangerous, and their use should be limited. However, they are one of the few devices that secure the wrists in such a way that they can be released quickly and reliably. Wrapping the wrists with soft cloth provides some protection for the wrists. Securing the handcuffs with the keyholes toward the hands is the reverse of standard police policy – for the same reason. If the keyholes are pointed up the arm, it is extremely difficult, even with a key, to remove them.

to a cruel queen. He felt his erection grow, amid the increasing fire from the oil. Soon his nipples were also afire. At first, he bore it stoically, but soon he began to whimper and, as his fantasies intensified the physical effect, to scream.

By wiggling sideways, he was able to pick up the cylinder of ice and hold it against one nipple, then the other, with his cuffed hands, but the cold of the ice was of little real effect because the burning sensation returned as soon as it was removed.

Desperately, he strained to reach his balls where the greater fire raged as he fought and strained against his bonds. However, the crisscrossed chain kept his hands pinioned in place.

Soon the fire became part of his world and he ceased struggling and let his fantasies carry him, occasionally moving an arm or a leg to reassure himself that he was still, indeed, pinioned and helpless.

Time passed in a haze of fantasy. Finally, John glanced over and saw that the cylinder of ice had vanished, leaving a pair of keys in a puddle on the floor. One part of his soul begged him to ignore the opportunity and return to his fantasies of helplessness and submission, but a new and more intense burning urged him to wiggle over to the keys and, after many tries, unlock the cuff holding his right hand.

Without waiting to free any other appendage, he rolled over and firmly grabbed his erect cock. His hand first stroked it gently and gradually became almost a blur as he continued to fight the chains with his other hand and

pinioned feet. The explosion was so ecstatic that it was almost painful, and John was splattered with the evidence of his own desire, so long denied by the chains. After a few moments of motionlessness, John reached out for the other key and began the process of returning to the mundane world.

Oil of wintergreen does produce a "distinct sensation" that should be tried out prior to incorporating it into any bondage activity (and should also be experienced by the dominant before he or she uses it on a submissive). Many people find it just strong enough for them to fantasize that they are undergoing extreme torture while mild enough so that it does not intrude on the fantasy.

The Enema

Equipment needed:
Enema bag and nozzle
Handcuffs
Handcuff keys
Butt plug
Lubricant

Elena carefully placed the keys on the coffee table before putting on the blindfold, locking her hands behind herself and kneeling naked on the throwrug to await Pete's arrival.

He was due in a few minutes, but Elena knew that the New York traffic was unpredictable. Although she knew that she could find the keys and free herself in seconds, the notion of being helpless for an indefinite time had an irresistible appeal. Kneeling in the air-conditioned apartment, she found the distant sounds of the city fading away, and time ceased its steady, linear tread.

She wiggled a bit and her nipples hardened as she remembered Pete's strong arms and how he had taken her to places she had only fantasized about. Yesterday on the phone, he had told her only that they were going to do

Self-bondage, as addressed in the previous scenario, can be one of the more risky D&S activities. However, the risk here is minimized by having the handcuff keys readily available.

"something new" today, and she had been in a state of excitement ever since. Remembering the touch of chains and rope, the burning caress of his whips, the stretched, filled feeling of his hand in her, she gasped aloud.

So engrossed in her memories had she become that she failed to hear the door open or the soft gasp of pleased surprised as her master saw the tableau his lady had arranged. Her first awareness that she was no longer alone came with a firm touch on the back of her neck and a whisper in her ear.

"Lovely, my lady, lovely; never have I seen submission more attractively presented."

She was so absorbed that it took a moment for her to remember where she was and for whom she waited. Then, she felt herself melt.

Pete effortless lifted her to her feet and hugged her; then, turned her around and unlocked the handcuffs. Elena let her hands hang passively at her sides awaiting her master's order. However, instead of speaking immediately, he lifted her blindfold, and she found herself looking at his impassive face as he dangled the open cuffs in front of her eyes.

"You didn't double lock them," he said sternly.

"I... I," she said in confusion.

"You didn't double lock them," he repeated.

Elena bit her lower lip and then said with a touch of defiance, "I wasn't going to struggle. I just wanted to feel them on."

"I don't care," Pete said, reproachfully. "You are my property, and I don't want my property damaged. This is a

Quality handcuffs have a "double-lock" mechanism that prevents the cuffs from tightening after they are put in place. This second lock has to be engaged separately from the primary lock which keeps the cuffs from opening.

formal order. Anytime you have handcuffs on, you will double lock them."

Elena dropped her eyes but felt a flush of pride. *He values me so much*, she thought. *I feel so protected and cared for.* Her tone was soft and submissive as she replied, "Yes, Master."

Gently, Pete took her chin in his hand and lifted her head until she met his eyes. With an impish grin, he reached around and gave her a sharp slap on the ass. "See that you do, wench."

Elena could contain herself no longer. Shifting from one foot to the other, she was the image of a five-year-old whose curiosity was battling self-control. "What are we going to do today?"

Pete smiled as he picked up his toy bag and put it on the coffee table with a substantial thump. Elena hovered around attempting to look over his shoulder as he unzipped the unmarked black bag. At first, she could see nothing but the expected confusion of whips, ropes, cuffs and other toys, but then he reached into a side pocket and extracted a orange rubber bag and a length of white tubing.

Elena abruptly dropped from her tiptoe position onto her heels and fell back a step as he turned.

I don't know, she thought. *I don't really know.* She and Pete had discussed enemas previously. She had been largely uninterested, but willing. She knew that he found the idea exciting but had been willing to delay experimenting with them while they explored other fantasies that they both shared.

One wonderful thing about being a dominant is that you can use your consensual authority to enforce safety rules. However, you should be extremely reluctant to attempt to use power in the vanilla realm. While many submissives claim to desire a 24/7 (24 hours a day/seven days a week) relationship, in reality, such a one-sided association often quickly pales.

Another exciting and rewarding thing about being a dominant is the expanding of a submissive's limits, showing him or her new pleasures and gratifications. However, no dominant should begin this expansion until a firm base of trust and mutual knowledge has been developed.

Not all submissives reach the state often called "The Float." It is a dreamlike, out-of-body condition brought on by intense stimulation in an atmosphere where profound trust obviates any need to resist the stimulation.

Her doubts must have shown on her face because Pete gave her a reassuring touch and then sat down and said, "Assume the position." At the familiar, longed-for command, she bent her naked body over his lap. The wool in his pants tickled a bit as she balanced herself with toes and fingers and waited for what she knew was going to come next.

The first slap, as always, was light, almost a caress. The next was sharper. By the tenth, Elena was fighting to keep still as her will and passion conflicted with the purely physical responses of her body. When Pete paused in the spanking to rub her ass with a soft, sensual rabbit skin, she gasped. Soon, she lost track of the separate impacts and who and what she was. Self dissolved into something else, something she could not explain or describe. She floated.

Finally, a part of her mind noted, without concern, that Pete had picked her up, carried her over to bed and removed his own clothing. She was lying on the bed luxuriating in the sensations as she heard Pete running water in the kitchen. Turning her head, she watched as he tested the water temperature with his hand before putting the orange enema bag under the faucet.

Elena felt a bit of unease, but the aftereffects of the spanking gave her a feeling of overall relaxation and compliance. In fact, she admitted to herself, she was curious about what an enema was like. Most of her hesitance had stemmed from fear of an "accident," but, at this point, she was too soothed by the spanking to really care.

Pete seemed so precise and competent as he finished filling the bag and attached the tube. He squeezed the bag

until a thin stream of water came out of the tip, and then closed the clamp, sealing the hose.

Putting aside the filled enema bag, Pete took several pieces of material out of his bag. Putting them on the side of the bed, he kissed Elena and said, "Roll over for a second, darling." Where she had been resting, he spread out a sheet of thin plastic and covered it with a soft towel. With the tips of his fingers, he indicated that Elena should roll back into her previous position.

Lying on her back, she watched as he hung the enema bag from one of the bedposts and gently spread her legs.

She gasped as he ran his thumb along her labia and gave her clit a quick rub. Putting a hand under each knee, he lifted her legs up and back until they rested against her breasts. "Hold them," he said, and she put her arms over her knees and held on to her wrists.

A vagrant gust from the air conditioner caressed her ass and pussy, reminding her how open and exposed she was. Despite her passion, a touch of reluctance remained. *Can't he just spank me more? I'm in such a perfect position for it*, she thought. However, she knew that such a plea would fall on deaf ears. Pete did what Pete wanted to do to her.

That thought triggered a flood of memories about the journey of erotic discovery her master had given her. She trembled a bit and felt her pussy chill as her juices flowed. His fingers traced erotic designs on her thighs and labia as she fought to hold her legs in the position he had commanded. He leaned forward, and his breath was fire

Fiction abounds with boiling water or freezing enemas. Reality is not so extreme. Safety hints are in the appendix on page 122.

An air of competence on the part of the dominant is very important to the submissive when embarking on an unfamiliar scene. This doesn't mean braggadocio or an air of false confidence. It means that you must practice what you are going to do and be completely familiar with possible scenarios so that you don't fumble or struggle with unfamiliar equipment.

on her body. By the time his tongue touched her moist skin, she was gasping. The touch was so electric that she lost her grip on her own wrists and her legs, but before they could straighten of their own accord, she grabbed each just behind the knee, pulled them back and, without instructions, spread them wide so as to make herself even more available to his touch.

Engrossed in the intensity of the touch of his tongue, she barely noted his finger playing first in her pussy and then carrying a heavy load of lubricant down to her ass. Slick as it was, it entered the tighter hole smoothly and easily. Automatically, she pulled harder on her knees, lifting her ass so he could have an easier entry.

His slippery finger explored the vestibule of her ass for a moment and then withdrew, replaced with the plastic of the enema tip. Unnoticed by Elena, warm water began to flow into her. Seduced by Pete's tongue, Elena thrashed about, holding her legs apart and pulling them until her feet were actually behind her head.

He stopped the dance of his tongue and slid up the bed until he was lying next to her. With gentle hands, he disengaged her grip on her knees and guided them back into a normal position. Spreading her legs a bit, he reached down and held the enema tip in place. With this gesture, Elena realized what was happening to her.

She could feel the warm water flowing into her most private opening. There was a sense of invasion which was quickly followed by a deep feeling of submission. Yet again, Pete had possessed a part of her of which she had barely

Plentiful lubricant is a requirement of any ass play.

Once any object or any part of your body has come in contact with the interior of the anus, it should not touch the vagina again before being thoroughly cleaned.

been aware. She felt owned, possessed; it was a wonderful, peaceful feeling.

As the amount of water in her increased, the feeling of flowing vanished, replaced by a feeling of fullness. Pete caressed her belly and pussy mound, whispering reassurances. When the first cramps hit her, Elena's eyes widened and she gave a small gasp. However, Pete's tender encouragement helped her almost immediately transform them into that special pleasure that they shared.

"Hold tight now," Pete said in almost a whisper and removed the tip. Elena felt an immediate need to shit and fought it.

"I don't know if I can hold it," she whispered.

"You can," Pete replied, but his slick finger again invaded her ass, and she had to squeeze tight to keep from embarrassing herself. When he removed his finger, Elena redoubled her efforts, but she almost lost control, when Pete removed a new toy from his toybag. Its bullet shape widened to about two inches before tapering to a narrow neck and spreading again to a wide double-ended "foot."

Pete liberally coated the butt plug with lubricant and had her raise her legs into the position in which she had been holding them before. The tension on her pussy and ass terrified her. She was certain that she would leak some of the quart or so of warm water with which Pete had filled her. Only with the greatest concentration could she keep her asshole properly clenched. Pete raised the plug and, then, slowly inserted it into Elena's ass. The penetration and the sense of vulnerability magnified her concern, but

A more conventional, but arguably less erotic, position is to have the recipient of an enema rest her head on her hands and kneel, ass in the air. However, the position Pete has placed Elena allows him to look into her eyes and caress the front of her body.

Dildos can be used in the ass as well as the pussy, but their shape makes them difficult for a submissive to grip. Any dildo used for ass play should have a flange that will prevent it from sliding completely inside. A specially made butt plug has a narrow neck to help in its retention.

as a greater and greater diameter of the plug penetrated, her concern transmuted to one that the enormous plug would simply split her in two.

Her face reddened, and her fingernails dug deeply into the insides of her calves. Suddenly, the widest part was past, and her asshole snapped back to a still distended but more manageable size. The relief was so abrupt and so welcome that it came as a burst of intense pleasure... pleasure so great that she released the conscious grip she had retained on her asshole. However, the butt plug performed admirably, and not a drop of fluid escaped. When she became aware of this state of affairs, Elena again sighed with relief.

Filled but safe, Elena luxuriated in the sensation. The cramps, never very intense, faded until they provided a muted counterpoint to their cuddling. Pete shifted, pulled and Elena found herself on top, Pete's cock first questing and then finding her pussy.

She felt herself become like one of those desktop wave-machines with the blue waves rocking back and forth in slow motion as Pete moved first slowly and then faster and faster until he climaxed and crushed her against him.

One small part of her mind was thankful that his strong arms were about her upper back. *If he squeezed me like that around the waist*, she thought with a tiny, internalized giggle, *I'd squirt all over the wall.*

Later, he had her squat over the toilet and, with her own fingers, slide the butt plug out. While she held the now familiar water in place, she dropped the plug next to the

toilet. Pete watched her for a moment, a prideful smile on his lips and, then, said a single word.

"Release!"

Elena set aside the internal grip that she had been maintaining and, like a rosebud unfolding, opened and released a gush of water that seemed to go on and on. As it ended, she shuddered and fell forward into her master's arms.

Appendix

HANDCUFFS. Handcuffs are common fodder for fantasies and pornographic tales. However, they can be extremely dangerous in real world play. Police obviously prefer restraints which will automatically "punish" anyone who resists. Because of this, handcuffs are designed in such a way that they can do both tissue and nerve damage to anyone who "fights" them. They are best reserved for purely psychological scenes and for decoration. Any handcuffs that will actually be used in play should have a double-lock feature that, once activated, prevents the handcuffs from continuing to tighten.

TRAMPLING. "Trampling" can be a very risky activity, but it has a tremendous psychological impact. After all, such phrases as "dirt beneath her feet" and "less than the dirt she walks on" are a part of our language for very good reason. However, full trampling (both feet) should only be attempted by relatively light women. Partial trampling (using one foot while the other, supporting a significant amount of weight, is on the floor) is safer.

In any case, it should be restricted to the main torso, and joints and the spine itself should carefully avoided.

Obviously, anyone with a history of back trouble should never be trampled.

The safest shoes for trampling are soft-soled sports shoes; unfortunately, few people have managed to fetishize Nikes. Bare feet are more erotic and allow a greater degree of control and balance. High heels are popular, but they can be dangerous. The thin heel can concentrate body weight to the extent that it can punch through metal - you can imagine what it could do to skin and muscle. Dominants who want to use high heels should practice walking using only the soles while bringing down the heel only for emphasis. Thick cardboard is a good medium on which to try this as it clearly shows how much pressure has been brought to bear.

ENEMAS. Fiction abounds with boiling water or freezing enemas. Reality is not so extreme. The intestines are relatively delicate and have a profusion of blood vessels. An enema at other than body temperature has a direct and immediate effect on the entire body. The safest temperature is one that is very close to the existing 98-99 degree temperature. Another common fictional enema involves using alcohol. It is true that the intestines will quickly transfer alcohol to the blood stream, putting the submissive into a drunken state; *however,* they are so efficient in this transfer that a fatal concentration of alcohol in the blood can be produced quite easily. Also, a drunken submissive cannot safely take part in any stimulation scenes.

Too much pressure can be dangerous with an enema, so most authorities recommend that the bag not be more than 18 inches above the submissive's body. Pure water is acceptable for an enema, but some medical authorities recommend adding two teaspoons of salt per quart to more closely match the ionic concentration of blood. Two quarts of water is the maximum recommended for a single enema.

SLAPPING. The most dangerous injury from face slapping is not to the skin and muscle, but to the brain which may be bruised if the head is moved quickly by an impact and to the spine which may be wrenched when the head moves. To deliver a "safer slap," hold one side of the face in one hand while striking the other side. This way, the head is not jerked about.

Index

SYMBOLS

24/7 119

B

blindfold 10

Bondage

14, 21, 30, 44, 50, 65

Butt plugs 123

C

Caning 107

Carrying 11

Cheval mirror 69

Clips 77

Clothespins 72

Cock/ball torture 72, 101

Cocooning 57

Collars 96

Condom 61

Crossdressing 95

Cunnilingus 46, 49, 122

E

Embarrassment 73

EMT scissors 34

Enemas 117, 128

Exhibitionism 51

F

Feedback 59

Fellatio 69, 83

Float 28, 54

Flogging 32, 33, 70

Food play 48

Foot masturbation 93

Foot worship 85

foot worship 26

Footworship 105

Forced Crossdressing 95

Forced stripping 40

Forced transvestism 95

French Maid 102

G

Golden Showers 109

Guided fantasy 9

H

Handcuffs 10, 19, 76, 120, 127

Humiliation 12, 41, 103

I

Ice 59

K

Kidnapping 63

Knife 15

Knife stripping 33, 68

L

Leather cuffs 14

M

Magic Shave 100

Massage 22, 43

Music 20, 40

O

Oil of Wintergreen 113

P

Public Scenes 63, 74

S

Safe signal 53, 65

Safeword 7, 52, 78

Self bondage 111

Sensory deprivation 56

Shaving 35, 97

Slapping 129

Slow word 70

Smell 11

Sound 11

Spanking 25, 51, 58, 70, 120

Strapping 31

Switch 70

T

Trampling 105, 127

W

Waxing 39, 61

Other Books from Greenery Press

BDSM/KINK

The Bullwhip Book
Andrew Conway $11.95

A Charm School for Sissy Maids
Mistress Lorelei $11.95

The Compleat Spanker
Lady Green $12.95

Family Jewels: A Guide to Male Genital Play and Torment
Hardy Haberman $12.95

Flogging
Joseph W. Bean $11.95

Jay Wiseman's Erotic Bondage Handbook
Jay Wiseman $16.95

The Loving Dominant
John Warren $16.95

Miss Abernathy's Concise Slave Training Manual
Christina Abernathy $11.95

The Mistress Manual: The Good Girl's Guide to Female Dominance
Mistress Lorelei $16.95

The New Bottoming Book
D. Easton & J.W. Hardy $14.95

The Sexually Dominant Woman: A Workbook for Nervous Beginners
Lady Green $11.95

The Topping Book: Or, Getting Good At Being Bad
D. Easton & C. A. Liszt $11.95

GENERAL SEXUALITY

Big Big Love: A Sourcebook on Sex for People of Size and Those Who Love Them
Hanne Blank $15.95

The Bride Wore Black Leather... And He Looked Fabulous!: An Etiquette Guide for the Rest of Us
Andrew Campbell $11.95

The Ethical Slut: A Guide to Infinite Sexual Possibilities
D. Easton & C.A. Liszt $16.95

A Hand in the Bush: The Fine Art of Vaginal Fisting
Deborah Addington $13.95

Health Care Without Shame: A Handbook for the Sexually Diverse & Their Caregivers
Charles Moser, Ph.D., M.D. $11.95

Look Into My Eyes: How to Use Hypnosis to Bring Out the Best in Your Sex Life
Peter Masters $16.95

Supermarket Tricks: More than 125 Ways to Improvise Good Sex
Jay Wiseman $11.95

Turning Pro: A Guide to Sex Work for the Ambitious and the Intrigued
Magdalene Meretrix $16.95

When Someone You Love Is Kinky
D. Easton & C.A. Liszt $15.95

FICTION FROM GRASS STAIN PRESS

The 43rd Mistress: A Sensual Odyssey
Grant Antrews $11.95

Haughty Spirit
Sharon Green $11.95

Justice and Other Short Erotic Tales
Tammy Jo Eckhart $11.95

Love, Sal: letters from a boy in The City
Sal Iacopelli, ill. Phil Foglio $13.95

Murder At Roissy
John Warren $11.95

The Warrior Within (part 1 of the Terrilian series)
Sharon Green $11.95

The Warrior Enchained (part 2 of the Terrilian series)
Sharon Green $11.95

Please include $3 for first book and $1 for each additional book to cover shipping and handling costs, plus $10 for overseas orders. VISA/MC accepted. Order from:

greenery press

1447 Park St., Emeryville, CA 94608
toll-free 888/944-4434 http://www.greenerypress.com